T0270264

Walking East Harlem

Walking
East Harlem

A Neighborhood
Experience

Christopher Bell

RUTGERS UNIVERSITY PRESS

New Brunswick, Camden, and Newark, New Jersey
London and Oxford

Rutgers University Press is a department of Rutgers, The State University of New Jersey, one of the leading public research universities in the nation. By publishing worldwide, it furthers the University's mission of dedication to excellence in teaching, scholarship, research, and clinical care.

Library of Congress Cataloging-in-Publication Data
Names: Bell, Christopher, 1968– author.
Title: Walking East Harlem : a neighborhood experience / Christopher Bell.
Description: New Brunswick : Rutgers University Press, [2025] |
Includes bibliographical references and index.
Identifiers: LCCN 2024003633 | ISBN 9781978836532 (paperback ; alk. paper) |
ISBN 9781978836549 (epub) | ISBN 9781978836556 (pdf)
Subjects: LCSH: Walking—New York Metropolitan Area—Guidebooks. | Neighborhoods—
New York (State)—New York—Guidebooks. | Harlem (New York, N.Y.)—Guidebooks.
Classification: LCC GV199.42.N65 B45 2025 |
DDC 974.7/1044—dc23/eng/20240527
LC record available at https://lccn.loc.gov/2024003633

A British Cataloging-in-Publication record for this book is available from the British Library.

Unless stated all photographs are from the author's collection.

References to internet websites (URLs) were accurate at the time of writing. Neither the author nor Rutgers University Press is responsible for URLs that may have expired or changed since the manuscript was prepared.

∞ The paper used in this publication meets the requirements of the American National Standard for Information Sciences—Permanence of Paper for Printed Library Materials, ANSI Z39.48-1992.

rutgersuniversitypress.org

To the late Gina Rusch,
Gerald Meyer, Gil Fagiani, Rose Pascale,
and Mario Cesar Romero, members of
the East Harlem Historical Organization,
and Morgan Powell, former Bronx
historian and resident

Contents

Preface

Walking East Harlem does not discount the plethora of public housing projects built in the neighborhood; these buildings receive acknowledgement. The book's theme is to highlight East Harlem through its historical buildings, organizations, and mural artwork. The book comprises three walking tours that profile the residences of famous entertainers, artists, and politicians from East Harlem, and it focuses on the museums, cultural centers, and landmark buildings that tell the neighborhood's and the city's history.

Tour 1: Lower East Harlem includes many cultural locations and prestigious sites. Highlights include Cicely Tyson's residence, where the talented performer was reared and later left an incomparable legacy in theater and film; the Conservatory Garden, the neighborhood's hidden jewel; and Mount Sinai Hospital, the world-renowned medical institution. You will also find the New York Academy of Medicine, a repository of medical research that has contributed to the nation's health, and the former location of the Manhattan School of Music, where many great musicians were educated and trained and honed their craft.

Tour 2: Middle East Harlem comprises many diverse sites. Highlights include Alice Neel's residence, where the great portrait artist lived anonymously before achieving worldwide fame and acclaim; Tito Puente Way, in honor of the great Latin percussionist; Fiorello LaGuardia's former home; the former Ansche Chesed Synagogue, one of the last neighborhood synagogues; and La Marqueta, once East Harlem's mega shopping center.

Tour 3: Upper East Harlem represents a distinct residential neighborhood. The tour highlights the brownstone where the iconic *Great Day in Harlem* photograph was taken; the Elmendorf Church, one of the oldest churches in the Harlem community; the oldest frame house, built during the Civil War; and the iconic Harlem Courthouse.

Tourists can also see many of the neighborhood's murals. One of them depicts the legendary poet Julia de Burgos. The Graffiti Hall of Fame mural and the inspirational *Spirit of East Harlem* mural continue to attract art enthusiasts.

The tours also profile the former enclave of Italian East Harlem and the former home of the African American literary giant Langston Hughes, who was once called the "Dean of Black writers." The book also recognizes the contributions of the Puerto Rican–Latino experience, including El Barrio Artspace, El Museo del Barrio, Julia de Burgos Latino Cultural Center, and the Caribbean Cultural Center. I encourage readers to come and see East Harlem when the sun shines on the neighborhood.

Walking East Harlem

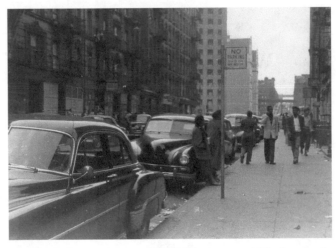

100th Street between First and Second Avenue 1953. This photograph
shows East Harlemites walking in their neighborhood. The tenements
were indicative of the way many people in East Harlem lived. Many
mom-and-pop stores and other businesses lined the block, catering to
the residents who lived there. The tenements were demolished in the
early 1970s. A street sign for Norm and Peg Eddy, ministers who lived
on the block and were part of the East Harlem Protestant Parish,
a local interdenominational ministry that once existed on the same
block, was dedicated in their memory.

Introduction

East Harlem is in the northeastern section of Manhattan. The neighborhood encompasses the area from East 96th Street to 142nd Street between Fifth Avenue and the East River. It was part of Nieuw Haerlem (New Harlem) when the Dutch founded it in 1658 and is home to the Dutch Reformed Church, the oldest church in Manhattan. Shortly after the Dutch settled in the area, the Negro Burial Ground, which held the remains of African descendants, was established in East Harlem. Today, that location is near 126th Street between First Avenue and FDR Drive. Later, during the mid-nineteenth century, this location and Harlem were reclassified as part of the Twelfth Ward, spanning the West and East Sides from 86th Street to 142nd Street in upper Manhattan, or Washington Heights. East Harlem was considered a suburb by this time, as its sparse population stood at fifteen hundred.

The Second and Third elevated subways, constructed during the late 1870s, led to the development of tenements and brownstones throughout the neighborhood. East Harlem's population increased overnight. African American churches and enclaves existed in the lower and upper

1

parts of East Harlem. The neighborhood became a transitional base as new immigrants settled in East Harlem. German and eastern European Jews soon joined German and Irish immigrants. Jewish East Harlem existed from Fifth Avenue to Lexington Avenue.

Italian immigrants arrived in the neighborhood in the late nineteenth and early twentieth centuries. Italian East Harlem was located from 100th Street to 120th Street between Third Avenue and the East River, becoming one of the United States' largest "Little Italys." At one time, East Harlem was home to thirty-five different ethnicities and twenty-seven different languages. The anti-immigration statutes of the 1920s reduced eastern European immigration to the neighborhood. Jewish East Harlemites left the neighborhood, as better housing was constructed in the Bronx and the West Side. Although some Puerto Ricans already lived or worked in East Harlem, by the turn of the twentieth century and in the ensuing years, Puerto Ricans moved to the area once inhabited by Jews in large numbers. This location quickly became Spanish Harlem, or El Barrio. The boundary lines for this enclave were 100th Street to 116th Street between Fifth and Lexington Avenues. East Harlem housed many old dumbbell tenements constructed during the nineteenth century. Many of these buildings were without proper ventilation and sunlight.

In the early twentieth century, the neighborhood was congested and overpopulated. East Harlem's population

stood at over 300,000. By the 1930s, the anti-immigration statutes enacted a decade earlier began to reduce East Harlem's population. Still, the poor housing conditions, low incomes, and other health concerns led to the Mayor's Committee on Public Housing in 1937, spearheaded by Mayor Fiorello LaGuardia. The report made recommendations that would change the neighborhood forever, specifically, the destruction of streets and the consolidation of several blocks into one super-block to build public housing. Many tenements were razed and replaced by public housing projects from 1940 to the mid-1960s. Italian East Harlem also declined during this period. From 1970 to 1980, East Harlem's population further declined by 25 percent, and by the early 1990s, East Harlem's population stood at 110,000. In the twenty-first century, East Harlem's population has grown along with many small businesses, which now adorn the blocks throughout East Harlem. It is estimated that 125,000 to 130,000 residents now live in the neighborhood.

Part I

Tours

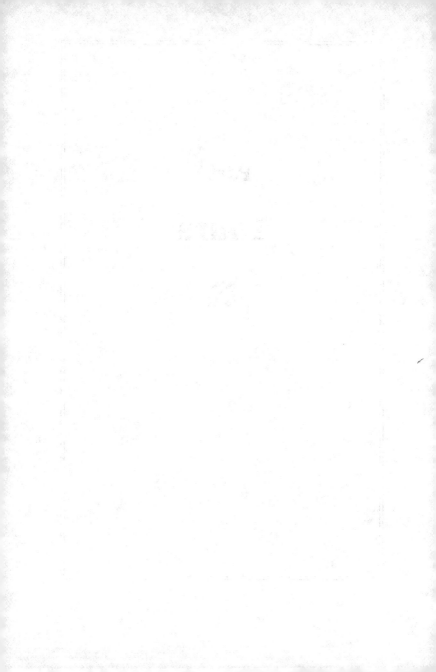

Tour 1

Lower East Harlem

1. Islamic Cultural Center of New York
2. El Barrio Artspace (Formerly Public School 109)
3. Cicely Tyson Residence
4. St. George and St. Demetrios Church
5. Harlem Jewish Children's School
6. Mount Sinai Hospital, Guggenheim Pavilion, and Icahn School of Medicine
7. Marian Anderson Residence
8. New York Academy of Medicine
9. Museum of the City of New York
10. August Heckscher Theatre / El Museo del Barrio
11. Conservatory Garden
12. Graffiti Hall of Fame
13. Spirit of East Harlem Mural
14. Manhattan Neighborhood Network El Barrio Firehouse Community Media Center (Formerly Firehouse 53)
15. Hope Community Hall (Formerly 28th Police Precinct)
16. Park East High School (Formerly Manhattan School of Music)

▶ Take the 6 subway to 96th Street, walk one block east to Third Avenue, and turn left. Or take the Q subway to 96th Street, walk one block west to Third Avenue, and turn right. Or take the the M101, M102, M103, or M98 bus to 97th Street and Third Avenue.

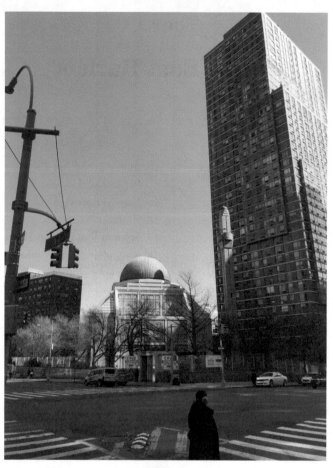

Islamic Cultural Center of New York.

Tour 1, Site 1
Islamic Cultural Center of New York

1711 Third Avenue, corner of 96th Street

Construction of this building, designed by the Skidmore, Owings, and Merrill architectural firm (founded during the 1960s), began in 1987 and was completed in 1990. The center was first housed in a tenement building on 72nd Street. The center opened to the public the following year.

► Walk two blocks north on Third Avenue, turn right, and arrive at Site 2.

Tour 1, Site 2
El Barrio Artspace
(Formerly Public School 109)

215 East 99th Street, between Second and Third Avenues

This building, landmarked in 2018, was designed by the architect Charles B. J. Snyder, superintendent of school buildings. Construction commenced in 1899, and it was completed in 1901. That same year, a reconstituted Board of Education ushered in a new wave of massive construction of school buildings. Several years before, the New York State legislature passed a new law that compelled parents to send their children to school. After this measure was

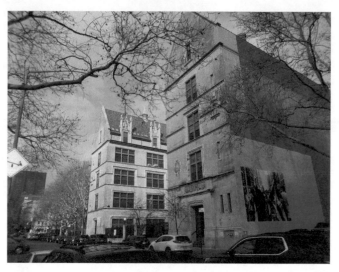

El Barrio Artspace (formerly Public School 109).

enacted, the school buildings were insufficient to educate the many children in the city, whose population increased due to the massive immigration from southern and eastern Europe.

Early in the twentieth century, nearly fifty schools were built. Charles Snyder's stewardship lasted from 1891 to 1923. He was an innovator whose designs were heralded by the late nineteenth- and early twentieth-century school reform movement. Some of the buildings included air ventilation. Snyder was also given credit for the H-plan school designs. Snyder also advocated for playrooms and an assembly hall.

Public School 109 closed in 1995. The building was spared from demolition when it received recognition from the National Register of Historic Places in 2000. Eleven years later, Artspace assumed ownership of the building and restored the outer façade and terra-cotta ornaments. In 2015, the former school was transformed into a live/work space for artists.

► Walk back to Third Avenue and cross the street, make a right, and head north toward 101st Street. Make a left, walk toward Lexington Avenue, and arrive at Site 3.

Tour 1, Site 3
Cicely Tyson Residence

178 East 101 Street, between Lexington and Third Avenues

This Old Law Tenement was built in 1910. Cicely Tyson (1924–2021) lived in East Harlem and attended Junior High School 99 (formerly Margaret Knox Junior High), known today as Julia de Burgos Middle School. Some of Tyson's memorable roles include parts in *Sounder*, *The Autobiography of Miss Jane Pittman*, *Roots*, *Hoodlum*, *Diary of a Mad Black Woman*, *The Help*, and *How to Get Away with Murder*. She received the Tony Award for her performance in *The Trip to Bountiful*. Presently, this is a five-story, sixteen-unit residential building.

Cicely Tyson's former residence.

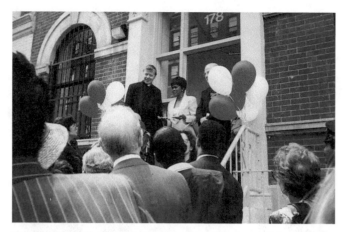

Tyson is greeted by East Harlemites at the dedication of the Cicely Tyson House. (© 1994 by Leo Bailey)

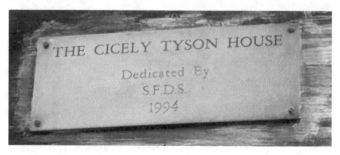

The Cicely Tyson House plaque.

► Cross Lexington Avenue, walk north across 102nd Street and down Deadman's hill, and arrive at Site 4.

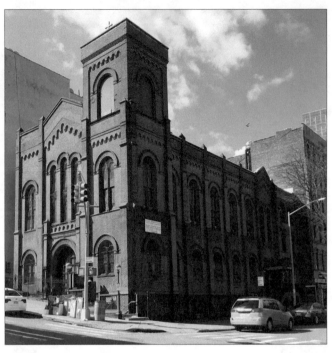

St. George and St. Demetrios Church.

Tour 1, Site 4
St. George and St. Demetrios Church

140 East 103rd Street, at intersection of Lexington Avenue South

This church was built in 1891 in the Romanesque Revival style. The location first served as the Blinn Memorial Methodist Episcopal Church, until it ceased operations in 1930. A year later, St. George Orthodox Church moved in.

In 1934, this church merged with St. Demetrios and was renamed St. George and St. Demetrios Church.

► Cross to the north side of 103rd Street and arrive at Site 5.

Tour 1, Site 5
Harlem Jewish Children's School

143–145 East 103rd Street

The building was built in 1900 and operated as the Harlem Jewish Children's School during the 1930s. It also served

Former Harlem Jewish Children's School. (Photo courtesy of New York Public Library)

as the location for the publication of the progressive periodical the *Morgan Freiheit*, with a sign that says, "Workers! Your newspaper is the *Morgan Freiheit*." Presently, occasional businesses operate at this location, owned by 143 Properties.

▶ Head west toward Park Avenue, walk under the Metro North tunnel, cross the street, turn left, and walk south to 102nd Street. Head west past Madison Avenue to Fifth Avenue, turn left, walk south to 101st street, and arrive at Site 6.

Tour 1, Site 6
Mount Sinai Hospital, Guggenheim Pavilion, and Icahn School of Medicine

1190 Fifth Avenue (East 101st Street)

The hospital began as the Jews Hospital in 1852. In 1904, Mount Sinai Hospital relocated to the block from 99th Street to 100th Street between Fifth and Madison Avenues. Two buildings were constructed on 99th and 100th Streets at a cost of over $2 million and housed 456 beds. Portions of the original buildings were demolished in the years after World War II. The surviving structures of the original buildings were demolished in 1986.

In 1936, a bridge was built over 100th Street and connected the Houseman Pavilion and the Guggenheim

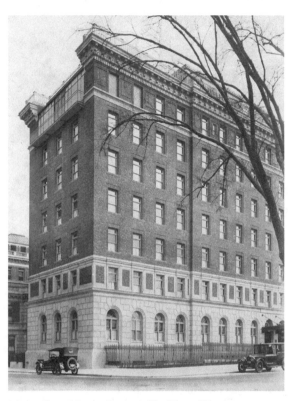

Mount Sinai Hospital's original building. (Photo courtesy of the Arthur H. Aufses, Jr., MD Archives, Icahn School of Medicine at Mount Sinai, Mount Sinai Health System, New York, NY)

Pavilion from the eighth floor to the seventh. Both floors were operating room areas. The Mount Sinai Hospital expanded its services and facilities throughout the ensuing decades, and in 1968, it welcomed the School of Medicine,

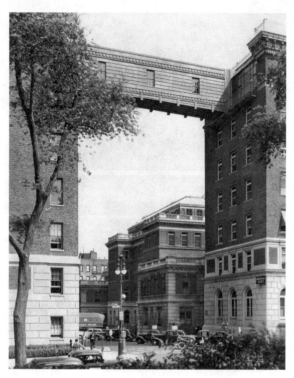

Mount Sinai Hospital at 100th Street and Fifth Avenue in the 1950s. (Photo courtesy of the Arthur H. Aufses, Jr., MD Archives, Icahn School of Medicine at Mount Sinai, Mount Sinai Health System, New York, NY)

which was renamed the Icahn School of Medicine in 2012 after a generous donation to the hospital from the philanthropist Carl Icahn. Mount Sinai Hospital first opened the Guggenheim Pavilion in 1922.

The latest incarnation of the hospital was designed by

the famed architect I. M. Pei and opened in 1992. The Guggenheim family were successful businesspersons who later became involved in philanthropy in the arts, culture, and medicine. The Guggenheim Pavilion stretches from Fifth

Present location of Mount Sinai Hospital, Guggenheim Pavilion. (Photo courtesy of the Arthur H. Aufses, Jr., MD Archives, Icahn School of Medicine at Mount Sinai, Mount Sinai Health System, New York, NY)

Avenue to Madison Avenue and is a 625-bed medical unit. This hospital has become a premier medical facility worldwide in its third century.

► Cross to the north side of 101st Street and arrive at Site 7.

Tour 1, Site 7
Marian Anderson Residence

1200 Fifth Avenue

Marian Anderson (1897–1993) was barred by the Daughters of the American Revolution from singing before an integrated audience in Constitutional Hall in Washington, DC. Anderson's resilience became evident in 1955 when she became the first Black American contralto to perform at the Metropolitan Opera. She lived here from 1958 to 1975. During her stay at this residence, Anderson was awarded the Presidential Medal of Freedom in 1963. The building was built in 1928. Presently, it is a seventeen-story condominium, home to fifty-one units.

► Walk north on Fifth Avenue toward 103rd Street and arrive at Site 8.

Marian Anderson's former residence.

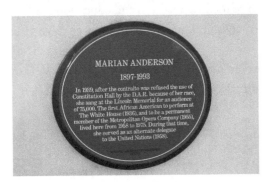

MARIAN ANDERSON

1897-1993

In 1939, after the contralto was refused the use of
Constitution Hall by the D.A.R. because of her race,
she sang at the Lincoln Memorial for an audience
of 75,000. The first African American to perform at
The White House (1936), and to be a permanent
member of the Metropolitan Opera Company (1955),
lived here from 1958 to 1975. During that time,
she served as an alternate delegate
to the United Nations (1958).

Marian Anderson plaque.

Tour 1, Site 8
New York Academy of Medicine

1216 Fifth Avenue, at intersection of 103rd Street

Construction commenced on this building, designed by the architects York and Sawyer, in 1925 and was completed in 1926. The five-story edifice, constructed of both limestone and sandstone, was built in the Italian Renaissance (Byzantine and Romanesque) Revival style. Founded in 1847 by New Yorkers concerned about the inadequate focus on ensuring the city's and nation's health, the New York Academy of Medicine has become the standard in medical research and advocacy for a healthier society. The academy has hundreds of thousands of books, pamphlets, and literature regarding the nation's health. Its library not only is a repository of studies in medicine but is second only to the United States Surgeon General's library in its selection of medical research and educational information. Its indispensable knowledge and advice have helped the nation become a healthier society. The organization has become even more important during the COVID-19 crisis. The institution is a Museum Mile participant.

▶ Walk north on Fifth Avenue, cross 103rd Street, and arrive at Site 9.

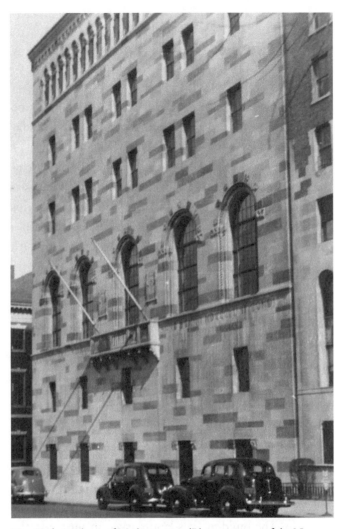

New York Academy of Medicine 1937. (Photo courtesy of the New York Academy of Medicine)

Tour 1, Site 9
Museum of the City of New York

1220 Fifth Avenue, between 103rd and 104th Streets

Current hours: Friday through Monday, 10:00 a.m. to 5:00 p.m.; Thursday, 10:00 a.m. to 9:00 p.m.; closed Tuesday and Wednesday.

Construction of this building, designed by the architect Joseph H. Freedlander, commenced in 1929 and was completed in 1930. Designed in the Georgian style, this five-story red-brick building, surrounded by white marble, transports visitors into a place of comfort and warmth. All New Yorkers who convene in this museum can discover the city's history in East Harlem. The museum opened in 1923 and was originally located in Gracie Mansion. Upon entering the museum, visitors are immediately mesmerized by the rotunda. Other notable museum features include the stairwell that ascends to the second floor. Upon arrival here, visitors enter Marble Court and gaze at magnificent views of Central Park. Along with the many exhibitions that have been presented at the museum, participants can always rely on the permanent exhibition *New York at Its Core*, which documenting the city's five-borough history. Statues of New York icons Alexander Hamilton and DeWitt Clinton can be seen on opposite sides of the museum. The building was landmarked in 1967, and the institution is a Museum Mile participant.

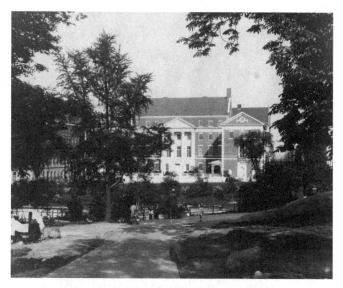

Museum of the City of New York from Central Park. (Photo courtesy of the New York Academy of Medicine)

► Walk north on Fifth Avenue, cross 104th Street, and arrive at Site 10.

<div align="center">

Tour 1, Site 10

August Heckscher Theatre (El Museo del Barrio)

1230 Fifth Avenue, between 104th and 105th Streets

</div>

Current hours: Thursday through Sunday, 11:00 a.m. to 5:00 p.m.; closed Monday through Wednesday.

August Heckscher Theatre (El Museo del Barrio).

This neoclassical building and theater opened in 1922 as the Heckscher Theatre for Children, named after August Heckscher (1848–1941). Later, this location served as an orphanage. By the 1930s, Broadway hopefuls appeared on this stage before heading down the "Great White Way." The Federal Theatre Project, a New Deal program, sponsored children's plays. These plays included *The Bunk of 1926*, *The Young Idea* (1932), *The New York Idea* (1933), and *Flight* (1936). In the 1950s and 1960s, the offices of Joseph Papp's Shakespeare Festival were located here. Several Shakespearean plays were produced at this theater, such as *Richard III* (1957), *As You Like It* (1958), *Julius Caesar* (1962), *Macbeth* (1962), and *Twelfth Night* (1963). During the 1980s and early 1990s, off-Broadway productions of

Mama I Want to Sing (1983) and *Mama I Want to Sing Part II* (1990) appeared at the theater. El Museo del Barrio opened in 1969, then representing Puerto Rican artists. Originally located in Harlem, El Museo was subsequently headquartered in several locations throughout East Harlem before it moved into the Heckscher Theatre in 1977. In the 1990s, El Museo assumed control over the theater. Since its founding, El Museo has expanded and now includes all Latino artists. David Katz's architectural firm recently refurbished the murals and stained-glass art that were first designed by William Pogany in 1921. The institution is a Museum Mile participant.

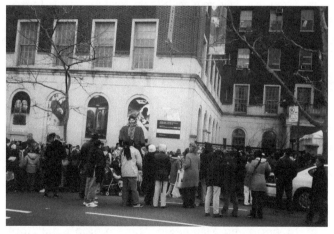

Participants prepare for the Three Kings Day (Los Tres Reyes de Magos) parade, an annual Latin American tradition that honors the Three Kings on January 6.

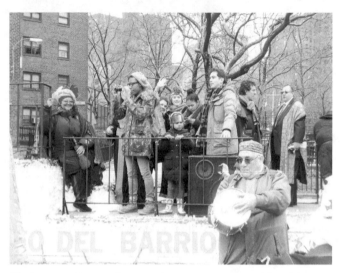

The longtime East Harlemite and artist extraordinaire Tiana Traverso happily waves to the people of El Barrio. She and other participants ride the elaborate floats.

► Cross Fifth Avenue and arrive at Site 11.

Tour 1, Site 11
Conservatory Garden

1233 Fifth Avenue, at intersection of 105th Street

Hours vary seasonally. January through February, 8:00 a.m. to 5:00 p.m.; March, 8:00 a.m. to 6:00 p.m.; April, 8:00 a.m. to 7:00 p.m.; May through August 14, 8:00 a.m. to 8:00 p.m.; August 15–31, 8:00 a.m. to 7:30 p.m.; Sep-

tember, 8:00 a.m. to 7:00 p.m.; October, 8:00 a.m. to 6:00 p.m.; November through December, 8:00 a.m. to 5:00 p.m.

From 1898 to 1934, this location was a greenhouse called the "Conservatory." The greenhouse was demolished after its maintenance was deemed too expensive.

The Conservatory Garden, designed by Gilmore D. Clarke, opened three years later and was one of the pioneering works of the Works Project Administration. Parkgoers enter through the Vanderbilt Gates, which were donated to the Conservatory Garden by Gertrude Vanderbilt Whitney in 1939. This six-acre conservatory garden is separated into three sections.

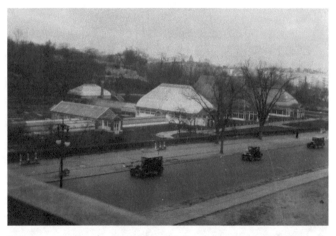

Conservatory greenhouses in 1927. (© Frank Place; photo courtesy of the New York Academy of Medicine)

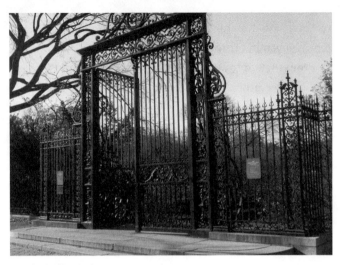

Vanderbilt Gates.

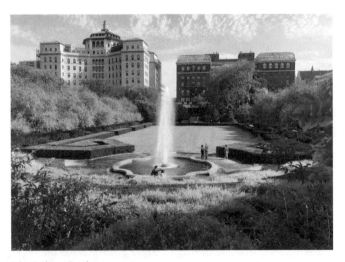

The Italian Garden.

The conservatory's unique sights include the Untermeyer Fountain in the southern section. It was donated courtesy of Samuel Untermeyer's family. The center section includes the Italian Garden, with a waterfall from the spring to fall seasons contiguous to the north and south entrances. Atop the far end of the garden is the curved iron pergola. Visitors can view the former Flower Fifth Avenue Hospital, the Museum of the City of New York, and the Heckscher Theatre. The original thirteen states are carved into the stone walkway for visitors to marvel at the intricate details. In the northern section lies the *Three Dancing Mermaids* (designed by Walter Schot), the Conservatory Garden Center Fountain, and a pool with a statue of Mary and Dickon from *The Secret Garden*. The conservatory's expanse declined post–World War II and further deteriorated during the 1970s. The urban designer Lynden Miller rescued the garden in the late 1980s and replanted in 2007.

► Exit the Conservatory Garden, walk north toward 106th Street, and turn right. Walk east to Park Avenue and arrive at Site 12.

Tour 1, Site 12
Graffiti Hall of Fame

Corner wall of intersection of 106th
Street and Park Avenue South

Tats Cru, a consortium of talented artists, annually designs
and decorates the wall associated with the Jackie Robinson
Educational Complex. This wonderful artwork beautifies
the school, and its elaborate detail makes this annual tradi-
tion a must-see for art lovers worldwide.

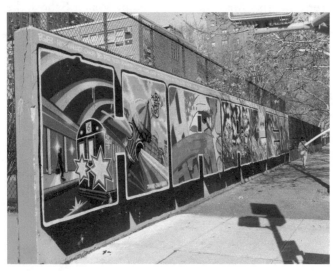

Graffiti Hall of Fame.

▶ Walk south on Park Avenue to 104th Street; turn left, walk east under the Metro North to Lexington Avenue, and arrive at Site 13.

Tour 1, Site 13
Spirit of East Harlem Mural

Intersection of 104th Street and Lexington Avenue

This wall mural was designed by the architect Hank Prussing in 1978. The idea for this wall began in 1973 when Prussing was enrolled at Pratt University and was hired by Hope Community to create an image that reflects the "spirit" of East Harlem. He took many photographs around East Harlem, and some of the images eventually appeared on this wall. Manny Vega, then an art apprentice who contributed to this project, repainted the wall in 1998. This five-year odyssey produced one of the neighborhood's most enduring images. This mural depicts the everyday life of East Harlem, El Barrio. The depictions on the wall include a rock performer, an older sister, a spiritual person, a teacher, a martial artist, and a bodega proprietor.

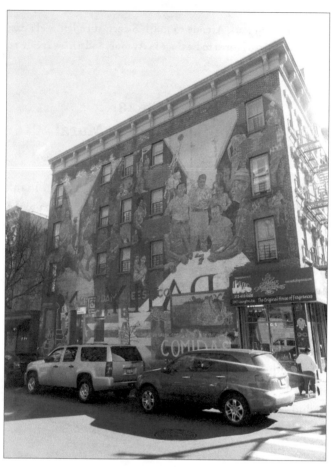

Spirit of East Harlem mural.

▶ Continue east on 104th Street until you arrive at Site 14, on the north side of the street.

Tour 1, Site 14

Manhattan Neighborhood Network El Barrio Firehouse Community Media Center (Formerly Firehouse 53)

175 East 104th Street

Current hours: El Barrio Firehouse Community Media Center, Tuesday through Friday, 1:00 p.m. to 7:00 p.m.; Saturday 11: 00 a.m. to 5:00 p.m.; closed Sunday and Monday.

Manhattan Neighborhood Network, founded in 1992, is an instructional center focusing on media production and distribution. It also fosters creative expression, independent thought, and community engagement. It provides top-notch and state-of-the-art media production for programs aired on local cable public-access channels. The firehouse was built in 1883 by the architectural firm Napoleon LeBrun and Sons, which specialized in firehouse construction. The firehouse closed in 1973. El Museo del Barrio leased the location until it moved again. See Site 10, Heckscher Theatre.

On the left is the Manhattan Neighborhood Network El Barrio Fire-
house Community Media Center (formerly Firehouse 53). On the
right is Hope Community Hall (formerly 28th Police Precinct).

▶ Right next door is Site 15.

Tour 1, Site 15
Hope Community Hall
(Formerly 28th Police Precinct)

177–179 East 104th Street

This building, designed by the architect Nathaniel Bush, was landmarked in 1999. Construction commenced in 1892 and was completed in 1893. Bush specialized in police precinct designs. This structure incorporated both the Renaissance Revival and Neo-Greco styles. The police station closed in 1973. Hope Community, a neighborhood housing organization, reopened and operated the building from 1981 to 1993, until the organization moved its offices across the street.

OFF-TOUR SITE

Union Settlement, 237 East 104th Street. Founded in 1895, Union Settlement is the last of the settlement houses in East Harlem. It has provided social services for seniors, youth, Meals on Wheels, and Head Start.

► Walk east toward Third Avenue, cross the street, and turn left; walk north to 105th Street and turn right; then east until you arrive at Site 16.

Tour 1, Site 16
Park East High School
(Formerly Manhattan School of Music)

230 East 105th Street, between Second and Third Avenues

The building was constructed in 1928, the first for the prestigious Manhattan School of Music, founded by Janet Schenck. The Manhattan School of Music was headquartered at this address until 1969, when it moved to its present

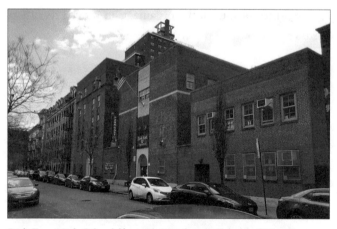

Park East High School (formerly Manhattan School of Music).

location on the Upper West Side. Many famous people studied at this school. The drummer Max Roach, John Lewis, Nicholas Flagello (later a member of the faculty), and Herbie Hancock are some students who attended the school. Harold Bauer, Anton Coppola, Pablo Casals, Friedrich Schorr (a former instructor with the Metropolitan Opera), the opera singer John Brownlee (eventual director of the school), the composer Ludmila Ulehla (a former student), and José Irturbi *all* taught at this location. In addition, Arturo Toscanini and Miriam Anderson both visited the school.

Tour 2

Middle East Harlem

1. Julia de Burgos Latino Cultural Center
2. Saint Cecilia's Church
3. Metropolis Studio (Formerly Odd Fellows Temple)
4. Alice Neel Residence
5. Fiorello LaGuardia Residence
6. The Africa Center
7. Harlem Meer
8. Tito Puente Way
9. Oscar García Rivera Post Office (Hellgate Station Post Office)
10. First Spanish Methodist Church
11. Congregation Ansche Chesed Synagogue (Now Christ Apostolic Church)
12. Urban Garden Center
13. La Marqueta

► From the end of Tour 1, walk west along 105th Street to Lexington Avenue. Turn right and proceed to Site 1. If you choose to do Tour 2 separately, take the 6 subway to 103rd Street, walk two blocks north on Lexington Avenue to 105th Street, and arrive at Site 1.

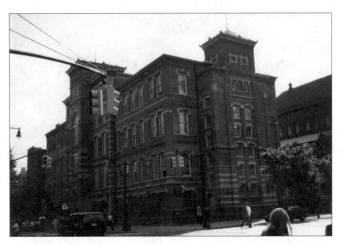

Julia de Burgos Latino Cultural Center.

Tour 2, Site 1
Julia de Burgos Latino Cultural Center

1674 Lexington Avenue, between East 105th and 106th Streets

This building, former Public School 72, was designed by the architect David Staggs in the Neo-Greco style. It was landmarked in 1996. Construction commenced in 1879 and was completed in 1882. Staggs was superintendent of public school buildings from 1872 to 1886. He was also a noted school architect whose career in this field lasted over fifty years. The Neo-Greco style departed from the conventional Italian style of housing construction that focused on narrow rooms. The school ceased operations in 1975.

Afterward, Touro College and community groups like the East Harlem Council for Community Improvement occupied this location. A massive renovation in 1994 and 1995 by the architects Lee Barrero and Raymond Plumey coincided with renaming the former school in honor of the writer and poet Julia de Burgos (1914–1953), who spent the last part of her life in East Harlem. Taller Boricua (Puerto Rican Workshop) and the Heritage High School now operate at this location. A Julia de Burgos mural by the artist Manny Vega is visible across the street, on the southeast corner of 106th Street, next to another mural, *Aquí Me Quedo* (Here I stay).

▶ Turn left on 106th Street and walk west to arrive at Site 2.

Tour 2, Site 2
Saint Cecilia's Church

120 East 106th Street, between Park and Lexington Avenues

This building, designed by the architects Napoleon LeBrun and Sons in the Romanesque Revival style, was landmarked in 1976. Construction commenced in 1883 and was completed in 1887. The Reverend Michael J. Phelan, known as the builder of churches, oversaw the church's construction. His specifications went down to the minute detail of how this religious house of worship would represent the

Saint Cecilia's Church.

community during this period. The church's construction coincided with the growth of East Harlem and its establishment as a thriving neighborhood. The construction of the Second and Third Avenue elevated subways in the late 1870s lured residents from the then-congested Lower East Side to East Harlem. This transportation service allowed East Harlemites to travel back and forth from downtown Manhattan to the neighborhood.

► Cross to the north side of 106th Street and arrive at Site 3.

Tour 2, Site 3
Metropolis Studio
(Formerly Odd Fellows Temple)

105 East 106th Street, near Park Avenue

The Odd Fellows Temple, designed by the architect Hugo Tausing in the modern Romanesque Style with limestone, brick, and terra-cotta, was built in 1928, a year before the stock market crash. It cost over a million dollars to construct and belonged to a fraternal organization. This

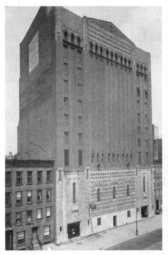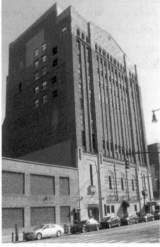

Left: Metropolis Studio; originally the Odd Fellows Temple and later Pathé Studio (Photo courtesy of the Museum of the City of New York). *Right*: Metropolis Studio today.

eleven-story edifice's dimensions are exactly one hundred by one hundred feet. The building was on the auctioneer's block a couple of years later. The Pathé studios acquired it in 1945. But, by 1960, the building suffered as the Pathé studio vacated the property. Several organizations used the facilities in the late 1960s to 1970s.

In the 1980s, Metropolis Studio acquired the facility. Viewers will recognize this location for the 1994 movie *Hangin' with the Homeboys*. Black Entertainment Television's *106 and Park* was filmed at this location. Dave Chapelle's *Chapelle Show* was also filmed at this location.

▶ Walk west and cross Park Avenue, under the Metro North, and continue to Madison Avenue to the Lakeview Apartments. Turn right and walk north to 108th Street, turn left, and arrive at Site 4.

Tour 2, Site 4
Alice Neel Residence

21 East 108th Street

This apartment building, which runs from Fifth to Madison Avenues, was built in 1910. One of the United States' greatest portrait artists, Alice Neel (1900–1984) lived in East Harlem from 1938 to 1962. She first lived in the neighborhood at 8 East 107th Street and 10 East 107th Street.

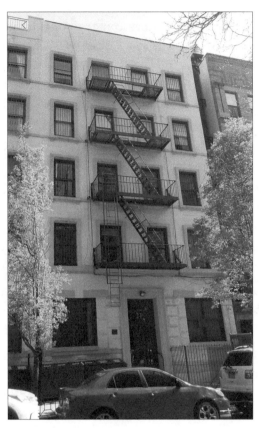

Alice Neel's former residence.

Both buildings were demolished to make way for the Lakeview towers. Her final East Harlem residence here at 21 East 108th Street still stands. Art critics noted that some of Neel's best portraits were produced when she lived

in East Harlem. Some of her iconic paintings include *T.B. Harlem* (1940), *Two Girls in Spanish Harlem* (1941), *The Spanish Family* (1943), *Hartley in a Rocking Chair* (1943), *Woman in Pink Velvet* (1944), *Girl in Pajama Suit* (1945), *Dead Father* (1946, an homage to the deceased George Washington Neel), *Mother* (1946), *Richard Neel* (1946), *Meyer Shapiro* (1947), *Bessie Boris* (1947), *Horace Cayton (Jr.)* (1949), *Alice Childress* (1950), *Mercedes Arroyo* (1952), *George Arce* (1953, 1955, and 1959), *City Hospital* (1954), *Dominican Boys* (1955), *Still Life* (1958), *Alvin Simon* (1959) *Rag in Window* (1959), and *Two Black Girls* (1959) Presently, this is a five-story, twenty-unit residential building.

▶ Walk west toward Fifth Avenue, turn right, walk north toward 109th Street, and arrive at Site 5.

Tour 2, Site 5
Fiorello LaGuardia Residence

1274 Fifth Avenue, at intersection of 109th Street

This apartment building was built in 1925. Fiorello LaGuardia (1882–1947), aka the "Little Flower," represented East Harlem in Congress from 1923 to 1933 and, during his first decade as mayor, lived here from 1933 until he moved into Gracie Mansion in 1943. Presently, this is a six-story, fifty-four-unit luxury residential building.

Fiorello LaGuardia's former residence.

▶ Cross to the north side of 109th Street and arrive at Site 6.

Tour 2, Site 6
The Africa Center

1280 Fifth Avenue, between 109th and 110th Streets

Current hours: Thursday and Sunday, noon to 8:00 p.m.; and Friday and Saturday, noon p.m. to 9:00 p.m.

The Africa Center culminates the Museum Mile. The center aims to build a relationship between the outside world and modern Africa. Its mission is to inform the world's understanding of Africa and the many people in

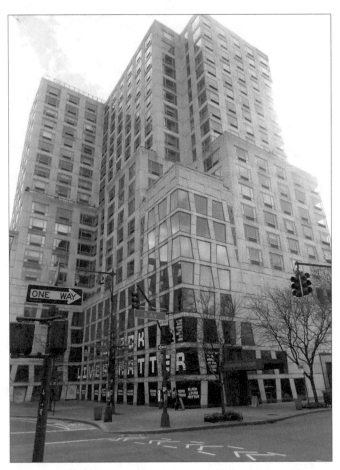

The Africa Center.

the African Diaspora. In 2019, the center introduced public programming. Thousands of visitors have participated in live performances, lively discussions, book readings, and films. Construction commenced in 2009 and was completed in 2011. It was designed by Robert Stern and occupies the former location of the Peace House, a location where the peace activist Edith Bryce Cram held pacifist meetings. The organization began in 1984 and was headquartered on 68th Street.

▶ Cross to the west side of Fifth Avenue and arrive at Site 7.

Tour 2, Site 7
Harlem Meer

Intersection of 110th Street and Fifth Avenue, stretching to Lenox Avenue

In the Dutch language, *meer* means "lake." The Harlem Meer spans eleven acres and stretches into West Harlem. It is the third-largest body of water in New York City, with only the Central Park Lake and New York City Reservoir being larger. The Meer was part of the brackish wetland of Montaye Rivulet (today called the Lock) and the Harlem Creek, a bay near the East River that once existed above ground. Next to the Harlem Meer is the Bernard Family Playground for children.

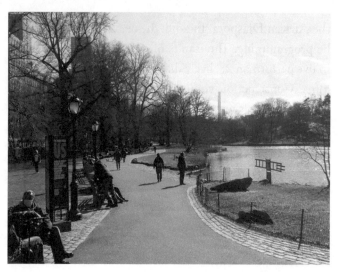

Harlem Meer.

▶ Walk up Fifth Avenue to 110th Street and arrive at Site 8.

Tour 2, Site 8
Tito Puente Way

110th Street, between Fifth and First Avenues

This street is named in honor of Ernesto (Tito) Puente (1923–2000), "El Rey de los Timbales" (King of the Timbales). Puente lived and spent most of his youth in East Harlem (El Barrio) on 110th Street and Madison Avenue. He is also known as the "El Rey," the king of Latin music.

He served in the US Navy during World War II. Upon his discharge, he enrolled in the Julliard School of Music. He recorded dozens of albums throughout his career. Of the many songs he made during his lifetime, "Oye Como Va" was popularized by Carlos Santana in 1970. Puente described himself as a street musician, performing on many streets in East Harlem or other parts of the city. In 1994, Puente returned to East Harlem and gave an outdoor concert at the Old Timer's Stickball Game. He appeared on-screen in *The Mambo Kings* and performed at the closing ceremonies at the 1996 Summer Olympics.

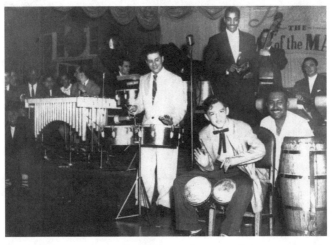

Tito Puente with the child prodigy Angel Rene performing at the Palladium, 1953. (Photo courtesy of Angel Rene)

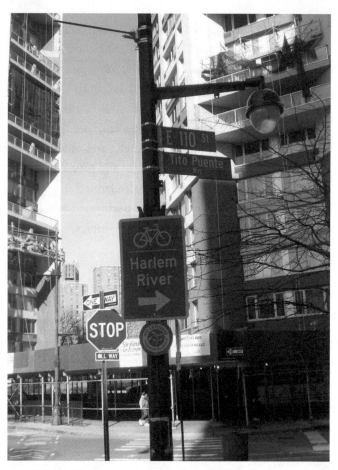

Tito Puente Way.

In August 2000, Tito Puente Way was dedicated in his honor. A statute bearing his likeness will soon appear opposite Duke Ellington in Frawley Circle on 110th Street. (The Tito Puente Mural appears on 110th Street and Third Avenue.)

▶ Head east along Tito Puente Way, across Fifth Avenue and past Madison, Park, and Lexington Avenues, and arrive at Site 9, on the north side of the street.

Tour 2, Site 9
Oscar García Rivera Post Office Station (Hellgate Station Post Office)

153 East 110th Street, between Lexington and Third Avenues

This post office was renamed in 2002 after Oscar García Rivera (1900–1969), the pioneering Puerto Rican politician and New York State assemblyman from 1937 to 1940. García Rivera was born in Mayagüez, Puerto Rico, to a prosperous family on the island. Upon his high school graduation, Rivera traveled to New York City and witnessed firsthand the struggles of the lower classes in the city. García Rivera wanted to help them. He secured employment in the New York City Post Office during the 1920s. In 1930, he earned his law degree from St. John's University and opened offices in lower and midtown

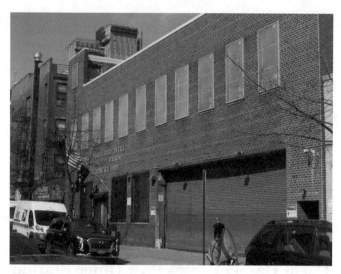
Oscar García Rivera Post Office Station.

Manhattan and East Harlem (El Barrio). Seven years later, he made history as the first native-born Puerto Rican to win elective office in the United States. He served two and a half years, until he lost his reelection in 1940. One of his notable achievements in the New York Assembly was the passage of the Unemployment Insurance Law in February 1939. After leaving office, he served as president of the Puerto Rican Bar Association in New York City.

▶ Return to Lexington Avenue, turn right, walk north to 111th Street, cross the street, and arrive at Site 10.

First Spanish Methodist Church

163 East 111th Street

Construction on this church, designed by the architect Lawrence Valk, commenced in 1880 and was completed in 1881. It was originally the Lexington Avenue Baptist Church. In 1964, the church suffered considerable damage from a fire; only parts of the first floor were salvageable. It was refurbished between 1966 and 1967. In December 1969, the Young Lords, mostly young Puerto Rican activists,

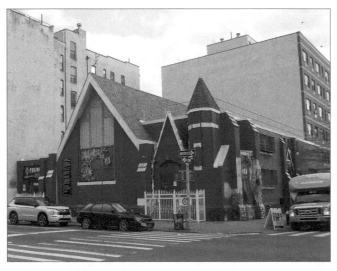

First Spanish Methodist Church.

seized the church to demand that New York City establish a free breakfast program for young East Harlemites. After eleven days, the Young Lords vacated the church, but they successfully achieved their goal, as New York City officials retrofitted the church and provided free breakfast for neighborhood children. Years after the Young Lords folded, the church retains the spirit of advocating for the rights of poor people. To East Harlemites, it is known as "The People's Church."

▶ Walk north on Lexington Avenue to 112th Street, make a right, and walk toward Third Avenue to arrive at Site 11.

Tour 2, Site 11
Congregation Ansche Chesed Synagogue (Now Christ Apostolic Church)

160 East 112th Street

From about 1877 to 1909, Congregation Ansche Chesed worshiped at this location. The current edifice was built in 1910. Another synagogue, Tikvath Israel (Hope of Israel) Congregation, operated at this location well into the 1970s.

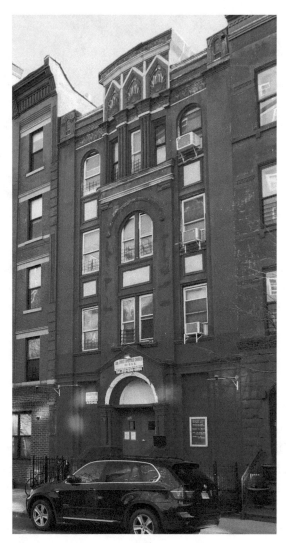
Former Congregation Ansche Chesed Synagogue.

Urban Garden Center.

▶ Walk west toward Lexington Avenue, cross the street, and continue to Park Avenue; turn right on Park Avenue, walk one block south, and arrive at Site 12.

Tour 2, Site 12
Urban Garden Center

1560 Park Avenue, between 111th and 112th Streets

Hours: Every day, 10:00 a.m. to 7:00 p.m.

Dimitri Gatanas is a third-generation garden proprietor in East Harlem. For over seventy-five years, the Gatanas family has been the premier provider of garden supplies and plants throughout New York City. Urban Garden Center is an outdoor garden that spans twenty thousand square feet and is located right in the heart of the neighbor-

hood under the Metro North subway. This establishment also advises all New Yorkers on designing their garden, preservation, and placement.

▶ Continue north on Park Avenue to 114th Street.

Tour 2, Site 13
La Marqueta

Park Avenue between 114th and 115th Streets

Many Puerto Ricans and Latinos shopped for produce at this market from the 1930s to the 1970s. It was first called

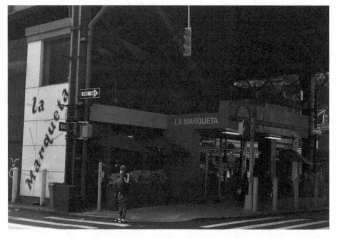

La Marqueta.

Park Avenue. As Puerto Ricans and Latinos moved to East Harlem, the marketplace became known as La Marqueta. Its first incarnation was an open-air market, but produce and refuse would litter the streets. It was enclosed in 1934 under the mayoralty of Fiorello LaGuardia. La Marqueta spanned three blocks from 112th to 115th Streets in its heyday. Fire destroyed much of the original structure in 1977. Since then, La Marqueta has occupied one block on this commercial strip.

Tour 3

Upper East Harlem

► From the end of Tour 2, head one block north to 116th Street, turn left, and continue to Fifth Avenue. Or if you choose to do Tour 3 separately, take the 6 subway to 116th Street, walk three blocks west on 116th Street to Fifth Avenue, and arrive at Site 1.

Tour 3, Site 1
Teatro Hispano (Now Church of the Lord Jesus Christ of the Apostolic Faith)

1421 Fifth Avenue, at intersection of 116th Street

This building, designed by the architects Hoppen and Koen and constructed in 1911, was initially called Mount Morris Theatre. It was also used as a synagogue. The location began displaying silent films by 1917. The theater ceased operations for a while due to incurred debts. As East Harlem transformed from a predominantly Jewish to a Latino enclave from Fifth to Lexington Avenues, 100th to 116th Streets, this movie theater catered to the Puerto Rican (Latino) community and played movies in Spanish. In 1934, it was called Teatro Campoamor, and two years later, it was called Teatro Cervantes. From 1940 on, the next generation knew it as Teatro Hispano. Finally, from 1959 to 1961, it was Teatro Santurce.

► Walk back down Fifth Avenue to 116th Street, and you are at Site 2.

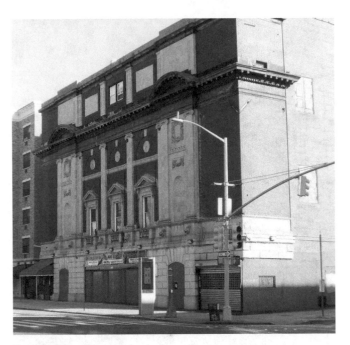

Former Teatro Hispano.

Tour 3, Site 2
Luis Muñoz Marín Boulevard

116th Street, between Fifth and Third Avenues

This street was named in honor of Luis Muñoz Marín (1898–1980), who in 1948 became the first elected Puerto Rican governor on the mainland and was later bestowed the Presidential Medal of Freedom by John F. Kennedy.

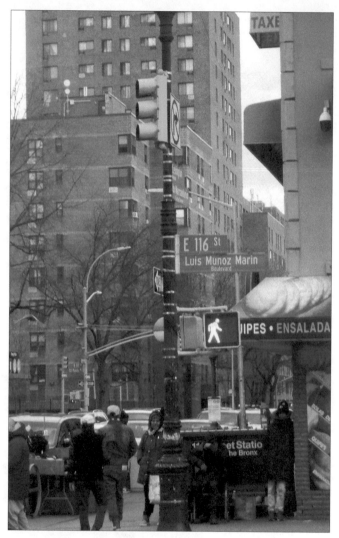

Luis Muñoz Marín Boulevard.

▶ Walk east on 116th Street toward Lexington Avenue until you arrive at Site 3.

Tour 3, Site 3
Vito Marcantonio Way, the Lucky Corner

Northeast corner of intersection of
116th Street and Lexington Avenue

This intersection is named in honor of the late congressman Vito Marcantonio (1902–1954), who was born in East Harlem on 112th Street and was a lawyer who served in Congress from 1935 to 1937 and 1939 to 1951. This progressive firebrand always said that he "voted his conscience." Originally, he ran as a liberal Republican. Later, he founded the American Labor Party (ALP). The Lucky Corner is a destination for many politicians and other political aspirants who would flock to this location to give a major speech or announce their candidacy. Many believe that this location will bring politicians "luck" or good fortune in their campaigns. This tradition still exists in East Harlem. Fiorello LaGuardia and later his protégé Vito Marcantonio held many political rallies at this site. Other notables to have appeared here include former president John F. Kennedy and former New York governor Mario M. Cuomo.

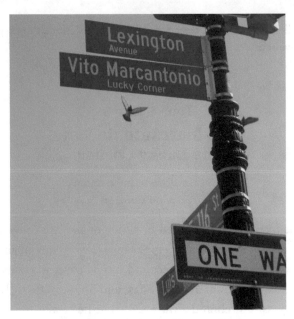

Vito Marcantonio Way, the Lucky Corner

▶ Cross Lexington Avenue and continue east past Third Avenue until you arrive at Site 4.

Tour 3, Site 4
First Sharon Baptist Church

233 East 116th Street, between Second and Third Avenues

This church was designed by the architect Henry Devoe in the Gothic Revival style and constructed in 1868. Reno-

vation occurred in 1931. From 1868 to 1887, it was the First United Presbyterian Church of Harlem. It was renamed the East Harlem Presbyterian Church from 1887 to 1924. This church coexisted with the First Magyar Presbyterian

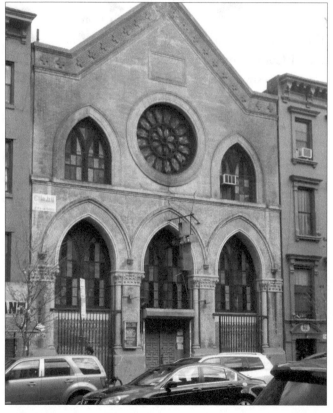

First Sharon Baptist Church.

Church. Both churches were associated with the American Parish until this organization folded in 1924. This location catered to many ethnic groups, as services operated in English, Spanish, Italian, and Hungarian. Norman Thomas, the grandfather of the writer Evan Thomas, ran as the socialist candidate for US president from 1928 to 1948. He ministered at this church from 1911 to 1918. The renowned Hungarian theologian Dr. Bela Vassady, a World Council of Churches member, spoke at the First Magyar Presbyterian Church in 1946.

▶ Continue east on 116th Street across Second Avenue and arrive at Site 5.

Tour 3, Site 5
Banco Commerciale Italia (Formerly Italian Bank)

2256 Second Avenue, at intersection of 116th Street

Banco Commerciale Italia (BCI) founded a subsidiary, Banco Commerciale Italia Trust Company (BCITC), in 1924 and built this bank in 1930 to collect deposits from Italian immigrants. Several years earlier, BCI opened a bank on Broadway to import goods and services from Italy to the United States. The company expanded to other cities throughout the Northeast during the late 1920s. This

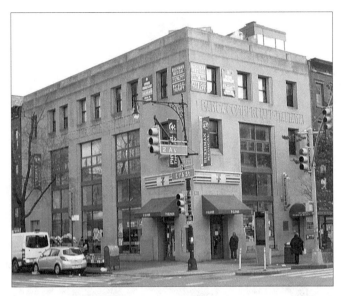

Banco Commerciale Italia.

venture lasted into the late 1930s, when BCITC liquidated and sold its properties to several banks. Presently, this three-story unit is available for rent, and 7 Eleven is the only business at this location. Another Italian (savings) bank was located at 204 East 116th Street, the present site of Ortiz Funeral Home (formerly Farenga Funeral Home).

► Cross to the north side of 116th Street and walk east until you arrive at Site 6.

LaGuardia Memorial House.

Tour 3, Site 6

Fiorello H. LaGuardia Memorial House
(Pete Pascale Way)

307 East 116th Street, between First and Second Avenues

This building is the former site of both Home Garden
Settlement and later Haarlem House Settlement. It was

named after former mayor Fiorello LaGuardia in 1956. Today, SCAN New York is the primary occupant at this location. Pete Pascale (1915–1997), a longtime Italian East Harlemite and social worker, worked at Haarlem and later LaGuardia Memorial House.

▶ Walk east to First Avenue, cross to the south side of 116th Street, continue east to Pleasant Avenue, turn right, and walk south until you arrive at Site 7.

Tour 3, Site 7
Manhattan School for Science and Mathematics (Formerly Benjamin Franklin High School)

260 Pleasant Avenue

This red-brick building surrounded by limestone, designed by the architect Eric Kebbon in the Georgian Revival style, was landmarked in 2018. Construction commenced in 1940 and was completed in 1942. This magnificent school building, resplendent in its construction, is a testament to the visionary Leonard Covello (1887–1982). He was principal of the former Benjamin Franklin High School from 1934–1956. Covello believed in East Harlem's children and felt they should have a state-of-the-art facility to learn and harness their ability to make positive changes

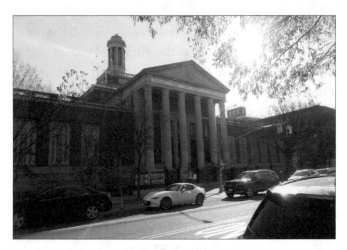

Manhattan School for Science and Mathematics.

within the neighborhood. His focus on a community-centered school significantly improved housing, health, and community activism. Benjamin Franklin closed in 1982 and was renamed the Manhattan School for Science and Mathematics. It has since become part of the Pleasant Village community, which recently received recognition as a historic district.

▶ Walk south to 115th Street and turn right to arrive at Site 8.

Tour 3, Site 8
Mount Carmel Church

The official address is 448 East 116th Street, but the church's
entrance is on 115th Street between First and Pleasant Avenues

This church, designed by the architect L. J. O'Conner and
built in the Romanesque Revival style, has been dubbed

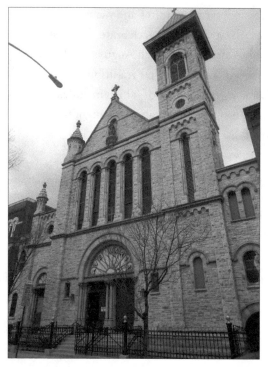

Mount Carmel Church.

"Church of the Italians." Construction began in 1884 and was completed in 1887. The former Florentine priest Emilio Kerner led the effort to build the church, with the assistance of Italian East Harlemites. One time, an estimated one hundred thousand Italian East Harlemites and Italian Americans paid homage to La Madonna at the annual festa. Though Italian East Harlem declined precipitously after 1950, this tradition continues each July. Former Italian East Harlemites and many Haitian Americans return to East Harlem to celebrate the feast of Our Lady of Mount Carmel. And each August, the Giglio Society of East Harlem keeps another tradition alive each year with the "Dancing of the Giglio," which includes dozens of men carrying an eighty-foot statute throughout the former section of Italian East Harlem.

► Continue west on 115th Street to First Avenue, turn left, and work south on First Avenue to arrive at Site 9.

Tour 3, Site 9
Thomas Jefferson Recreation Center

First Avenue, between 111th and 114th Streets

This location, including the swimming pool, bathhouse, perimeter terrace, and fencing, was landmarked in 2007. Construction commenced in 1935 and was completed

Thomas Jefferson Recreation Center.

in 1936. The architects were Stanley C. Brogren, Aymar Embury II, Henry Ahrens, and others. Landscape architecture was designed by Gilmore D. Clarke and others. This play center was one of nearly a dozen open-air pools that opened in 1936 and were built with Works Project Administration (WPA) funds. All pools constructed during this period were in the Art Moderne style and were constructed of brick and cast concrete. Thomas Jefferson Park first opened in 1905, and the original configuration included two playgrounds, two gymnasiums, baths, comfort stations, and a classical pavilion that provided shelter and recreation space. The structure remained intact at

112th Street and East River Drive until it was vandalized and ultimately demolished in the 1970s. Thomas Jefferson Park was enlarged in 1936 by then–Parks Commissioner Robert Moses. The Thomas Jefferson Recreation Center and its pool were renovated in 1992 by the architect Richard Dattner. The park's landscape was completed in 1994.

► Walk back up First Avenue to 114th Street and turn right to arrive at Site 10.

Tour 3, Site 10
Rao's Restaurant

445 East 114th Street, at intersection of Pleasant Avenue

Rao's, founded in 1896, is nestled on the corner of Pleasant Avenue. This exclusive, quaint restaurant has ten tables and a very long extended reservation list, but patrons say that it is worth the wait. Many famous patrons—entertainers, sports celebrities, and elected officials—have dined at Rao's Restaurant. Rao's has also appeared on-screen, such as in *The Wolf of Wall Street*.

► Walk back west toward First Avenue, turn right, and walk three and a half blocks north to arrive at Site 11.

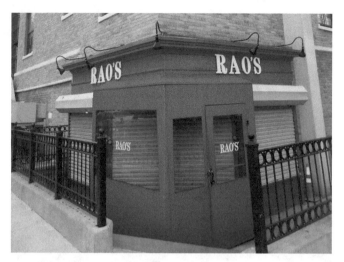

Rao's Restaurant.

Tour 3, Site 11
Patsy's Pizzeria

2287 First Avenue, between 117th and 118th Streets

The original Patsy's was founded in 1933 by Pasquale (Patsy) Lancieri. Patsy's opened during the Depression's early years. The financial breakdown that burdened the country escaped Patsy's during this period. Patrons flocked to Pasty's to enjoy its coal-oven and thin-crust pizza. Patsy's continues to thrive in its ninth decade. Many patrons who once lived in East Harlem or visited the restaurant will travel here to enjoy Patsy's pizza.

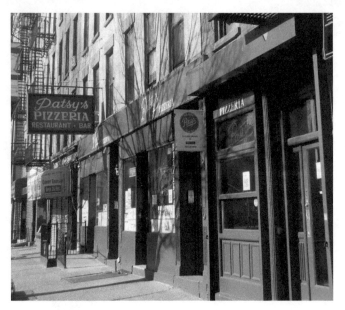

Patsy's Pizzeria.

▶ Walk north to 119th Street, turn left, and walk west past Second Avenue, until you arrive at Site 12.

Tour 3, Site 12
Richard Webber Packing House

207–215 East 119th Street, between Second and Third Avenues

This building, designed by the architects Bartholomew & John P. Walther in the Romanesque Revival and Renaissance Revival styles, was landmarked in 2018. This six-

story edifice was erected using brick and stone and was considered the best in building construction from that era. Work commenced in 1895 and was completed in 1897. Richard Webber (1847–1908) immigrated to New York from England in 1870 and opened his small East Harlem butcher shop in 1877. This profitable venture expanded to other businesses. Upon his death in 1908, he was reputed to

Richard Webber Packing House.

be the largest butcher in the United States. Presently, this is a contractors' warehouse, owned by Davis and Warshaw.

▶ Continue west on 119th Street across Third Avenue, cross to the south side of 119th Street, and arrive at Site 13.

Tour 3, Site 13
Center for Puerto Rican Studies (Centro de Estudios Puertorriqueños) at the Silberman School of Social Work–Hunter College)

2180 Third Avenue

The Center for Puerto Rican Studies (Centro de Estudios Puertorriqueños) was established in 1973 by a cadre of academics, civic leaders, and students to provide research, knowledge, and discovery of the Puerto Rican Diaspora. Affectionately known as "El Centro," it has over fourteen thousand books, twenty-five hundred dissertations, numerous newspaper articles, six hundred audio recordings, and five hundred videos. Originally housed in the Office of the Vice-Chancellor for Academic Affairs on 535 East 80th Street, the Center for Puerto Rican studies moved in 1983 to Hunter College on 68th Street. Much of the library's collection and archives was transferred to its present East Harlem location in 2012.

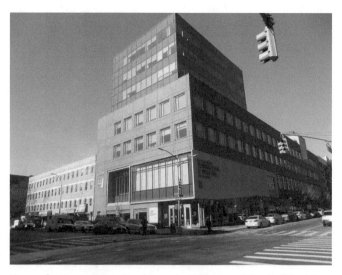

Center for Puerto Rican Studies at the Silberman School of Social Work–Hunter College

▶ Walk two blocks north on Third Avenue, turn left on 121st Street, and arrive at Site 14.

Tour 3, Site 14
Harlem Community Justice Center (Formerly Harlem Courthouse)

170 East 121st Street (Sylvan Place), between
Lexington and Third Avenues

This building, designed by the architects Thom and White in the Romanesque Revival style, was landmarked in 1967.

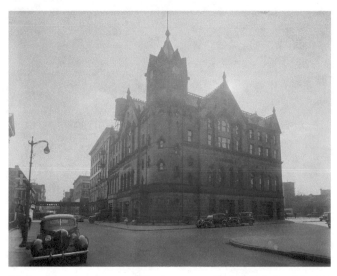

Harlem Courthouse, 1948. (Photo courtesy of New York City Municipal Archives)

Construction commenced in 1891 and was completed in 1893. Atop this four-story edifice stands the corner tower, supported by eight columns. Inside the columns are two distinctive round clocks that provide the visitor an insight into the neighborhood's environs during the last decade of the nineteenth century. The courthouse, formerly the Fifth District Prison, ceased operations in 1961. Afterward, this facility served three entities: the New York City Department of Air Pollution and Control, the Department of Sanitation, and the Parole Board. Today, this location is the Family, Housing, and Claims Division. It received

recognition from the National Register of Historic Places in 1980.

► Cross to the north side of 121st Street and arrive at Site 15.

Tour 3, Site 15
Elmendorf Reformed Church

171 East 121st Street, between Lexington and
Third Avenues, near Sylvan Court

This church traces its roots to the Low Dutch Reformed Church of the 1660s. It was added to the United States Register of Historic Places in 2010. The original location was at 125th Street and First Avenue. Then, the church was known as the First Collegiate Reformed Church, but that church was demolished during the Revolutionary War. The church would rise again during the mid-1820s, but it was built on 121st Street and Third Avenue. The church moved toward Lexington Avenue when Third Avenue became a business strip shortly after the Third Avenue El was built in 1880. The Reverend Joachim Elmendorf was selected as the pastor to lead First Collegiate Church in East Harlem. From 1893 to 1894, the architect John Ireland designed a neoclassical parish residence and Sunday school called the Elmendorf Chapel. This was renamed the Elmendorf Church in homage to Reverend Elmendorf,

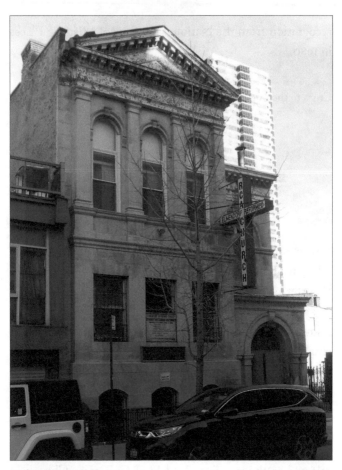

Elmendorf Reformed Church.

who died in 1908. In 1910, the church was demolished, though portions of the parish were spared, which became the location of the Elmendorf Church, which still stands today. In 2008, the church's original location discovered that African American descendants once lived there. The Harlem Burial Ground was established to advocate for an African American burial ground in this location, like its lower Manhattan counterpart.

▶ Walk west on 121st Street across Lexington Avenue, turn right, and then continue north on Lexington to 125th Street. Turn left and walk west until you arrive at Site 16.

Tour 3, Site 16
Caribbean Cultural Center

120 East 125th Street, between Park and Lexington Avenues

This landmarked building is the former Firehouse Number 14 and, later, Engine Company 36, which was decommissioned in 2003. The Caribbean Cultural Center, which specializes in the African Diaspora in the Caribbean, was founded by Marta Moreno Vega, who served as its first director from 1976 to 2018. The current director is Melody Capote. The Caribbean Cultural Center moved to its present location in 2016.

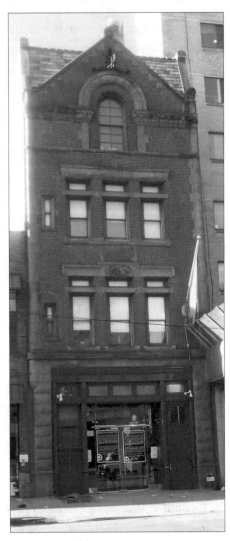

Caribbean Cultural Center.

► Walk two blocks west on 125th Street toward Madison Avenue, turn left, and walk south to 124th Street, and arrive at Site 17.

<div align="center">

Tour 3, Site 17
Marcus Garvey Park
(Formerly Mount Morris Park)

</div>

<div align="center">

The park's twenty acres span 120th to 124th
Streets and Madison to West Fifth Avenues

</div>

This park was renamed in honor of the African nationalist in 1973. It was the scene of the Harlem Cultural Festival featured in the recent 1969 biopic *Summer of Soul*. The fire

Marcus Garvey Park.

watchtower located on 122nd Street was landmarked in 1967. Originally called Slang Berg or Snake Hill due to its curvy configuration. The park was rebuilt in 1840 as Mount Morris Park, presumably in honor of the former New York City mayor Robert Morris. The New York City Parks and Recreation Department administers the park. Many New Yorkers partake in the Pelham Fritz Recreational Center, the Richard Rodgers Amphitheater, and the swimming pool during the summer months.

▶ Continue west on 124th Street to Fifth Avenue, turn right, and walk two blocks north to 126th Street. Turn right and walk east along the brownstones until you arrive at Site 18, on the north side of the street.

OFF-TOUR SITE

National Black Theatre, 2031 Fifth Avenue, east side of Fifth Avenue between 125th and 126th Streets. The theater was founded in 1968 by Barbara Ann Teer to preserve and develop African American cultural traditions. In 1983, Teer acquired the city block along 125th Street and built a spacious theater. A new housing complex will soon rise and become a state-of-the-art facility to provide space for aspiring actors and low-income housing for neighborhood residents.

Tour 3, Site 18
Great Day in Harlem Brownstone

17 East 126th Street, between Madison and Fifth Avenues

This brownstone was built in 1909. On August 12, 1958,
the photographer Art Kane (1925–1995) took an iconic
photograph of fifty-seven jazz musicians and neighbor-
hood children gathered in front of this brownstone. The
musicians include Red Allen, Buster Bailey, Count Basie,
Emmet Berry, Art Blakey, Lawrence Brown, Scoville
Browne, Buck Clayton, Bill Crump, Vic Dickenson, Roy
Eldridge, Art Farmer, Bud Freeman, Dizzy Gillespie,
Tyree Glenn, Benny Golson, Sonny Greer, Johnny Griffin,
Gigi Gryce, Coleman Hawkins, J. C. Heard, Jay C. Higgin-
botham, Milt Hinton, Chubby Jackson, Hilton Jefferson,
Osie Johnson, Hank Jones, Jimmy Jones, Jo Jones, Taft
Jordan, Max Kaminsky, Gene Krupa, Eddie Locke, Mar-
ian McPartland, Charles Mingus, Miff Mole, Thelonious
Monk, Gerry Mulligan, Oscar Pettiford, Rudy Powell,

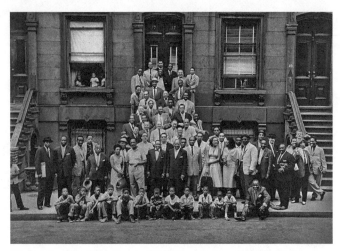

Harlem 1958 (A Great Day in Harlem), photograph by Art Kane.
(Used by permission of Photographs from the Art Kane Archive)

Lucky Roberts, Sonny Rollins, Jimmy Rushing, Pee-Wee Russell, Sahib Shihab, Horace Silver, Zutty Singleton, Stuff Smith, Rex Stewart, Maxine Sullivan, Joe Thomas, Wilber Ware, Dickie Wells, George Wettling, Ernie Wilkins, Mary Lou Williams, and Lester Young. Presently, the three-story brownstone houses four residential units.

▶ Walk back to Fifth Avenue, turn right, and head north past 127th Street until you arrive at Site 19.

Tour 3, Site 19
Saint Andrew's Church

2067 Fifth Avenue, near 127th Street

This church, designed by the architect Henry M. Congdon in Gothic Revival–style rock-faced granite, was landmarked in 1967. Construction commenced in 1889 and was completed in 1891.

► Walk back down Fifth Avenue to 127th Street and turn left. Walk east along the south side of the street until you arrive at Site 20.

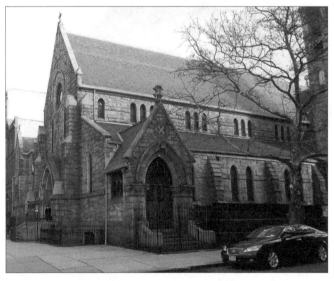

Saint Andrew's Church.

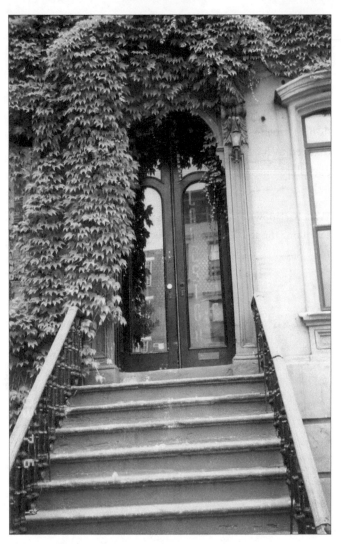

Langston Hughes House.

Tour 3, Site 20
Langston Hughes House

20 East 127th Street, between Fifth and Madison Avenues

This building, designed by the architect Alexander Wilson in the Italian style, was landmarked in 1981 and added to the National Register of Historic Places in 1982. It was built in 1869. The realtors James Meagher and Thomas Hanson looked to rent houses in the fashionable enclave of East Harlem. These row houses were the prototype of the many structures built in Harlem during the post–Civil War period. The Finnish community lived in the area during the early twentieth century. The writer Langston Hughes (1902–1967) purchased the property in 1947 and lived in the house during the last two decades of his life.

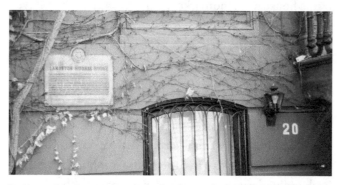

Langston Hughes House plaque by the Landmarks Preservation Commission.

► Walk back to Fifth Avenue and walk north one block to 128th Street. Make a right turn until you arrive at Site 21.

Tour 3, Site 21
East Harlem's Oldest Frame House

17 East 128th Street, between Fifth and Madison Avenues

This house, one of the small remaining frame houses from its era, was built in 1864 and landmarked in 1982. The architect is unknown. This structure is consistent with the paradigm design used to build frame houses during the mid-nineteenth century. Many of such houses were built in the area from 110th to 130th Streets. Abraham Overhiser owned the property when the house was constructed. A year later, James Beach purchased the property. When the frame house was landmarked, only five families had served as its owners.

This two-and-a-half-story frame house, supported by the elevated brick basement and with a mansard roof and dormer windows, allows light to reach the floor. The house was built during the period known as the Second Empire, from the reign of France's Napoléon III from 1852 to 1870, when East Harlem was still a rural enclave during and after the Civil War. Shortly after this house was built, the neighborhood underwent a drastic change through the elevated subways and construction of the neighborhood tenements.

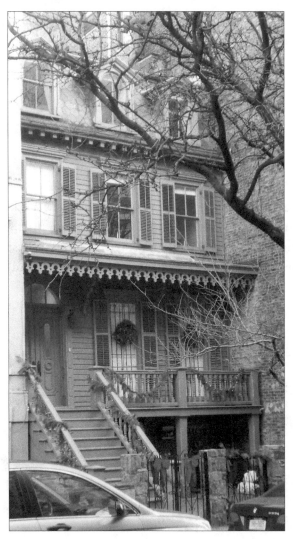

East Harlem's oldest frame house.

► Walk east across Madison Avenue, turn left, and walk one block north on Madison until you arrive at Site 22.

Tour 3, Site 22
All Saints' Church, Parish House, and School

47 East 129th Street

This church, landmarked in 2007, was once called the St. Patrick's Church of Harlem. Construction on the church commenced in 1888 and was completed in 1893; construction on the parish house commenced in 1886 and was

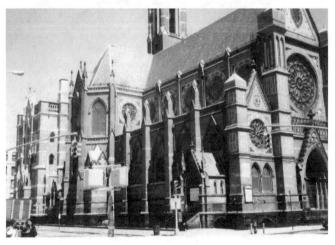

Former All Saints' Church.

completed in 1889; school construction commenced in 1902 and was completed in 1904. The architect James Renwick Jr. designed all in the Italian Gothic style. This church was hailed by many people in the architectural world as the best-designed church out of the many buildings Renwick designed during his career, including St. Patrick's Cathedral and the Smithsonian Institute. The architectural firm of Renwick, Aspinwall & Russell played a role in many of the churches designed during the late nineteenth century. James Renwick's nephew, William, designed the school in the same Gothic style that his uncle did for the church. Unfortunately, the school closed in 2011; in 2015, the church closed, and its congregants joined St. Charles Borromeo to worship in West Harlem. The church was deconsecrated two years later. In 2021, the property was sold to a realtor. Its landmark status will ensure that the exterior will remain intact. A charter school is scheduled to occupy this location.

Part II

Notable Places and People of East Harlem

Notable Places

Public Housing in East Harlem: New York City Public Housing Authority

Abraham Lincoln Houses

DeWitt Clinton Houses

East River Houses

Edward Corsi Houses

Gaylord White Houses

George Washington Carver Houses

George Washington Houses

Jackie Robinson Houses

James Madison Houses

James Weldon Johnson Houses

Lehman Village Houses

Lexington Houses

Metro North Houses

Robert Taft Houses

Robert Wagner Houses

Thomas Jefferson Houses

Woodrow Wilson Houses

Places of Interest

Doctor's Row, Italian East Harlem (Little Italy), 116th Street, First to Pleasant Avenues. On this street once stood private houses and brownstones where doctors, lawyers, and other white-collar professionals resided. Many in Italian East Harlem never ventured to the hospital unless it was an emergency. The doctor, with his black bag and medical equipment, would visit the patient, or the patient would visit the doctor at this location.

El Barrio Artspace, 215 East 99th Street. East Harlem Art entered the twenty-first century with El Barrio Artspace when it opened in 2015. It provides artists affordable apartments and space for organizations. A Minnesota-based company that focuses on property development, asset management, and consulting services, Artspace also provides affordable apartments to artists. Artspace has current or future programs in over twenty states throughout the country.

El Museo del Barrio, 1230 Fifth Avenue. El Museo del Barrio was founded in 1969 when Puerto Rican parents, community leaders, and educators advocated for a museum to represent the Latino community. Originally, it was located at Public School 25 on 425 West 125th Street and part of School District 4. But when the district lines were divided

Doctor's Row in Italian East Harlem.

into both East and West Harlem, District 4 was redrawn to encompass all of East Harlem. Raphaël Montanez Ortiz was the museum's first director. El Museo del Barrio moved throughout several locations in East Harlem before its present location at the Heckscher Theatre.

Harlem Art Park.

Harlem Art Park, 120th Street and Sylvan Court, between Lexington and Third Avenues. The park is ensconced between the former Harlem Courthouse and Casabe Senior Center. It is open to the public between 8:00 a.m. and 8:00 p.m.

Pleasant Village Community Garden, 342 Pleasant Avenue, between 118th and 119th Streets. Current hours: Saturday and Sunday, 10:00 a.m. to 2:00 p.m., from the beginning of April to the end of October. Participants can plant a seed in the garden and watch it grow and blossom. Children often visit the garden after school and marvel at the flowers and chicken coop. A compost site is also part of the community garden. Fruit peels, eggshells, vegetables,

flowers, coffee grinds, tea bags, grass, and old potting soil are some items used for composting. This community garden has become a mainstay and has outlasted other community gardens throughout the neighborhood. Other neighborhood gardens were lost to the city for redevelopment.

Taller Boricua (Puerto Rican Workshop), 1674 Lexington Avenue. The roots of the Taller Boricua began when members of the East Harlem branch of the Real Great Society, once headquartered near 111th Street and Madison Avenue, helped the organization incorporate. Adrian Garcia, Armando Soto, Martin Rubio, Rafael Trufino, and

Pleasant Village Community Garden.

Carlos Osorio were the original artists. Later, Fernando Salicrup, Marcos Dimas, and Nitza Trufino (Rafael's daughter) played a major role in providing a forum and location for artists. Taller Boricua shared space with the Real Great Society and remained at this location after the East Harlem Real Great Society was defunded in the early 1970s. Then it moved to 104th Street and Madison Avenue. Today, it is located at the Julia de Burgos Latino Cultural Center.

Murals

East Harlem's murals bring life and color throughout the neighborhood. Each mural was designed by many talented artists whose work can be viewed on many neighborhood walls throughout East Harlem. Their themes cover many Latina and Latino "sheroes" and heroes.

Facing page: The back of Artspace wall inside Cherry Tree Park, East 99th Street between Second and Third Avenues. *Top*: woman lying next to a cat; *bottom*: multiethnic women emitting colorful fire from their bodies. Cherry Tree Park hours: 6:00 a.m. to 9:00 p.m., March 2–October 31; 6:00 a.m. to 6:00 p.m., November 1–March 1.

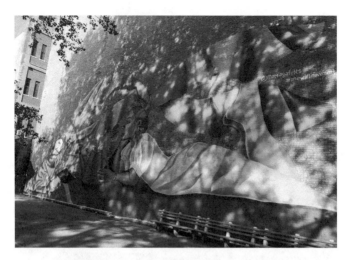

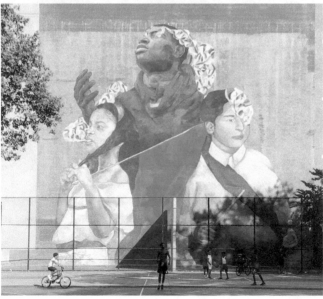

Notable Places 109

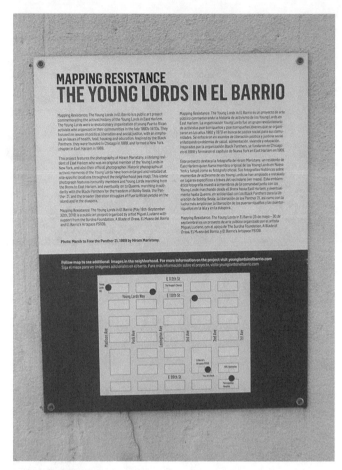

The "Mapping Resistance: The Young Lords in El Barrio" art project, on the side of Artspace, at 99th Street between Second and Third Avenues, features photographs by the East Harlem photographer Hiram Maristany (1945–2022); several other photographs are located throughout several East Harlem streets.

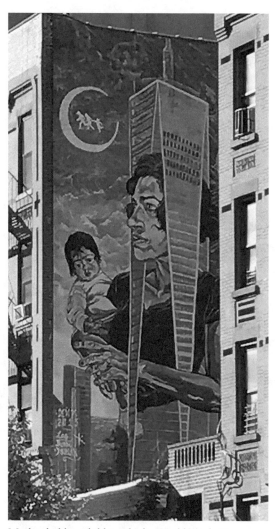

Mother holding child inside the World Trade Center,
100th Street between Lexington and Third Avenues.

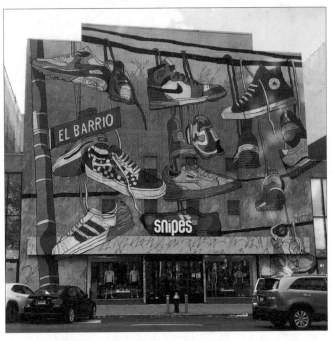

Sneaker mural at the former Eagle Theatre on Third Avenue between 102nd and 103rd Streets.

Weather Wheel in the outdoor yard of Public School 72, near 104th Street and Lexington Avenue.

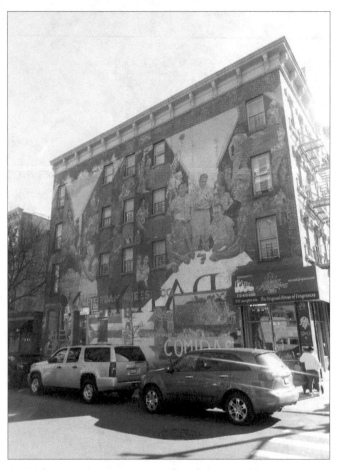

Spirit of East Harlem, intersection of 104th Street and Lexington Avenue. See Tour 1, Site 15.

Soldaderas (Soldiers), Hope Community's Modesto Flores Garden, Lexington Avenue between 104th and 105th Streets.

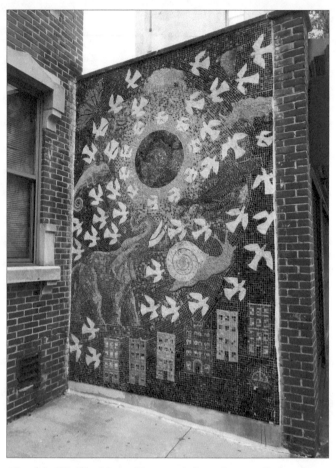

City of the World by Manny Vega, 104th Street between Park and Lexington Avenues.

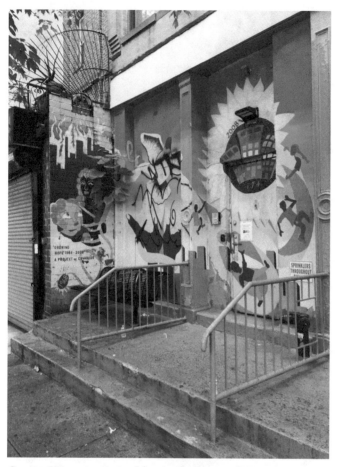

Growing Hope 1968–2008, celebrating forty years of Hope Community, 104th Street and Third Avenue.

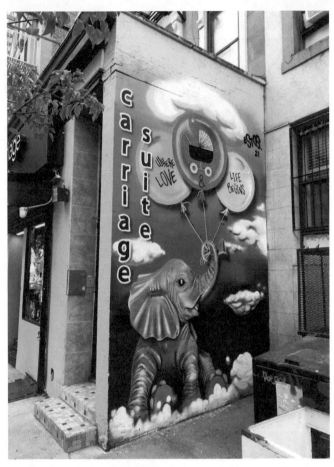

Carriage Suite: Where Love & Life Begins, 104th Street near Third Avenue.

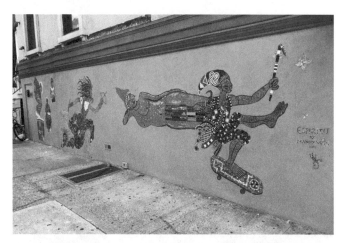

Espiritu by Manny Vega, on the corner of 105th Street and Lexington Avenue, features the former Beatle John Lennon (not shown here).

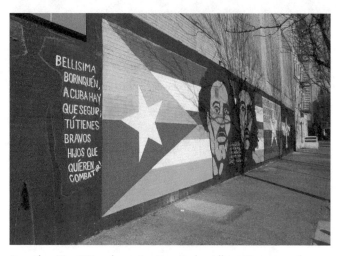

Dos Alas–Two Wings, honoring Don Pedro Albizu Campos and Ernesto "Che" Guevara, on 105th Street near Third Avenue.

Aquí Me Quedo (Here I Stay), 106th Street and Lexington Avenue.

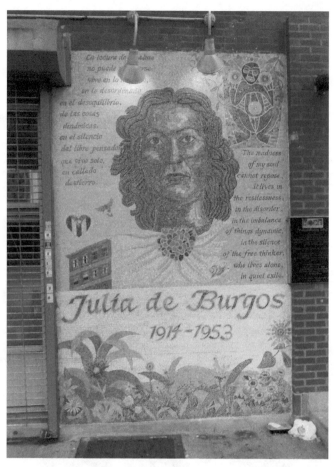

Julia de Burgos by Manny Vega, 106th Street near Lexington Avenue. See Tour 1, Site 12: Graffiti Hall of Fame.

Dragon mural, 108th Street and Third Avenue.

Child in red blanket, 109th Street and Third Avenue.

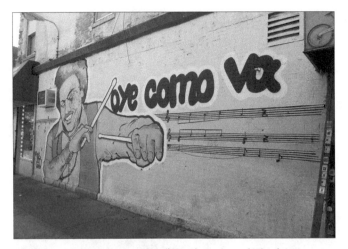

Oye Como Va (Tito Puente mural), 110th Street and Third Avenue.

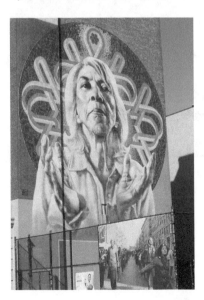

Nicholasa Mohr with outstretched hands, 111th Street and Lexington Avenue, inside PS 101 schoolyard, near Young Lords Way. A Young Lords art project photo by Hiram Maristany is visible on the schoolyard fence.

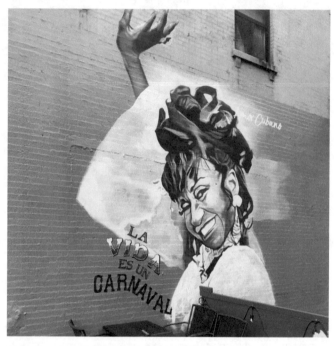

Celia Cruz mural on the back of Amor Cubano Restaurant, 111th Street and Third Avenue.

Mural featuring paint brushes, a family, a graduate, and a father holding his son playing basketball, PS 57, near 115th Street and Third Avenue. (© Tats Cru, Inc.).

Mural featuring a student working at computer, a father and daughter, a student and teacher, and a saxophone musician, PS 57, near 115th Street and Third Avenue. (© Tats Cru, Inc.)

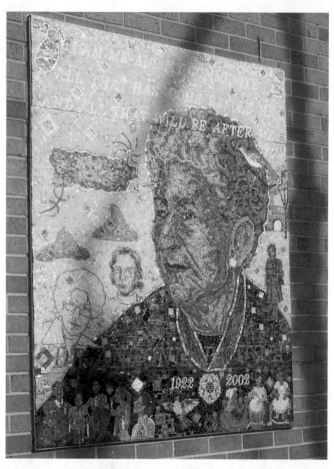

Dr. Antonia Pantoja (1922–2002) by Manny Vega, located on the LaGuardia Scan Memorial House, 116th Street between First and Second Avenues. Pantoja founded Aspira in 1961. Aspira provided mentorship to many young Puerto Ricans and Latinos. Many successful Latinos credited Aspira for providing them with leadership development and educational clubs.

Mural of a three-story tenement building on the side of PS 7, 117th Street and near Third Avenue.

Mother and children in pool, PS 7, 120th Street near Lexington Avenue.

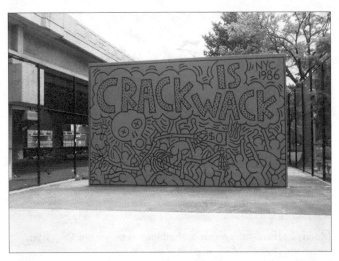

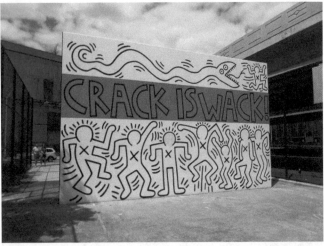

Crack Is Wack by the late Keith Haring, on 128th Street near FDR Drive. *Top*: one side of a handball court wall; *bottom*: the opposite side of the same handball court wall.

Movie Theaters

Many theaters opened during the late nineteenth and early twentieth centuries and featured vaudeville acts onstage. Silent films and talkies replaced vaudeville and appeared in the same theaters. Here are some of the theaters that existed in East Harlem during this period.

Atlas Theatre, 1888 Third Avenue near 104th Street. Operated between 1912 and 1923.

Casino Theatre, 2175 Third Avenue near 119th Street. Showed silent movies as of 1915.

Cosmo Theatre, 176 East 116th Street, between Lexington and Third Avenues. Opened in 1922 and closed in 1987. It is the last movie theater in East Harlem to date.

Eagle Theatre, 1852 Third Avenue, between 102nd and 103rd Streets. Built by 1926 and closed by 1980.

Fox Star (Boricua) Movie Theatre, 1716 Park Avenue near 107th Street. Initially owned by William Fox as a vaudeville theater, and later movies were shown there. The Fox Star closed and reopened as the Boricua Movie Theatre in 1952. The Boricua lasted until the late 1950s. The site

eventually became a meeting place until it was demolished in the 1960s.

Gotham Theatre, 165 East 125th Street between Park and Lexington Avenues. Originally called the Gotham Music Hall, this theater opened in 1903 and housed plays and vaudeville until movies were shown in the theater. Later, it was called the Triboro Theatre.

Madison (later Azteca) Theatre, 1490 Madison Avenue, near 102nd Street. Built around 1915 and lasted until the mid-1970s.

Mt. Morris Theatre (Teatro Hispano), 1421 Fifth Avenue and 116th Street. See Tour 3, Site 1.

New Pearl Theatre, 2078 Third Avenue near 114th Street. Showed silent movies between 1911 and 1923.

New Progress Theatre, 1892 Third Avenue near 105th Street. Existed from around 1919 to 1940.

North Star Theater, 1250 Fifth Avenue at 106th Street. Built in 1915 and closed by 1926.

Palace Theater, 2024 Second Avenue between 123rd and 124th Streets. The theater was operated by I. Silverman

and B. Marks and opened in March 1914. Customers enjoyed the sliding roof, which opened during the summer. By 1926, it was operated by the Meyer and Schneider circuit. It was still in operation in the 1950s.

Paraiso Theater, 1714 Madison Avenue between 113th and 114th Streets. Originally called New Madison Theatre and renamed El Municipal Theatre during the 1930s (nicknamed El Meaito "pissing pot" by many Latinos), it was renamed as the Paraiso Theatre by the 1950s and showed Spanish films until it closed around 1957. The block was demolished and became a super block for the Robert Taft Houses.

People's Vaudeville Theatre, 2172 Third Avenue between 118th and 119th Streets. First presented silent pictures by 1905 and continued for a decade.

Regal Amusement Theatre, 2028 Third Avenue near 112th Street. Opened around 1915 and closed by the 1930s.

RKO Proctor Theatre, 112–118 East 125th Street near Park Avenue. Oscar Hammerstein built this venue in 1890, then called Columbus Theatre. F. Proctor acquired the theater in 1899 and started showing vaudeville. RKO became the new owner during the 1930s. The theater lasted until the mid-1950s.

The Stadium Theatre (renamed the Sun Theatre), 2180 Third Avenue at 119th Street. Became one of the premier movie theaters to show films in Spanish. Closed by the 1940s.

Verona Theatre, 2094 Second Avenue near 108th Street. Opened around 1926. The Depression hampered its operations. The theater reopened several times under new names: the Victory Theatre and the Rex Theatre. By the late 1940s, this theater ceased operations.

Notable People

Entertainers and Celebrities

Marc Anthony, actor and singer, reared in East Harlem

Souren Baronian, clarinet and saxophone player

Ray Barretto, musician

Joe Bataan, singer

Mario Biaggi, former congressman

Chevy Chase, actor, lived in East Harlem during the early 1950s

Johnny Colon, musician

Common, rapper

Erik Estrada, actor

Lou Gehrig, baseball player, lived in East Harlem

Langston Hughes, writer

Fiorello LaGuardia, congressman and mayor of New York City

Burt Lancaster, actor, raised in East Harlem

Sinai Lathan, actress

The Marx Brothers, comedians, born in East Harlem

Rita Moreno, actress, the first performer to win an Oscar, a Tony, a Grammy, and an Emmy

Katherine Narducci, actress, reared in East Harlem
Alice Neel, painter
Al Pacino, actor, born in East Harlem
Tito Puente, percussionist
Jonas Salk, biomedical scientist
Tupac Shakur, rapper, born in East Harlem
Ed Sullivan, former pugilist and show host
Susan Taylor, editor of *Essence* magazine
Cicely Tyson, actress, lived in East Harlem
Malik Yoba, actor

Activists

The Last Poets were founded in Mount Morris Park (today Marcus Garvey Park) on May 19, 1968, three years after Malcolm X's death and what would have been his forty-third birthday. The original members were Abiodun Oyewole, Gylan Kain, and David Nelson. Felipe Luciano, Alafia Pudim (who became Jalauddin Mansur), and Umar bin Hassan joined later. Luciano's stay was short-lived, after he left to join the Young Lords. He would return to record the group's album *Right On* in 1970. A film of the same title was released the following year. The Last Poets are often credited as the progenitors of hip-hop music.

The Young Lords were founded on July 26, 1969, to commemorate the sixteenth anniversary of Cuban guerillas'

failed attempt to overthrow the Cuban president Fulgencio Batista's government, also known as the "26th of July Movement." Several Puerto Rican young adults and adolescents formed the Young Lords, which were headquartered on 111th Street and Madison Avenue. The Young Lords initiated several campaigns known as "offenses." One of the offenses led to the takeover of the First Spanish Methodist Church to advocate for a free breakfast program. The Young Lords occupied the church for nearly two weeks and were successful (see Tour 2, Site 10). This model was replicated, and now free breakfast is part of the New York City public school system. The Young Lords disbanded in 1975. Felipe Luciano, Juan Gonzalez, Juan "Fi" Ortiz, Pablo Guzman, and Mickey Melendez formed the initial cadre of the Young Lords. Later, Iris Morales, Denise Oliver-Perez, Ougie Robles, and other women advocated for inclusion in the hierarchy and became an essential part of the Lords.

Writers

East Harlem's literary history is as diverse as the neighborhood itself.

James Baldwin (1924–1987) was reared in East Harlem on 133rd Street and attended Public School 24 on East 128th Street between Fifth and Madison Avenues. Baldwin's

tenement building was demolished and replaced by the Abraham Lincoln Housing Projects during the late 1940s. Baldwin was first published in *The Nation* magazine in the late 1940s. This novelist, essayist, and playwright authored seventeen books, first coming to worldwide fame with *Go Tell It on the Mountain*, a quasi-autobiographical account of Baldwin's upbringing that was published in 1953 to critical acclaim. The book is part of *Time* magazine's 100 Best English Language Novels from 1923 to 2005. His next book, *Giovanni's Room* (1956), touched on homosexuality. Baldwin was openly gay. His other notable works include *Another Country* (1962), *The Fire Next Time* (1963), *If Beale Street Could Talk* (1974).

Julia de Burgos was a writer and poet who was born in Carolina, Puerto Rico. De Burgos was a gifted student who graduated college at age nineteen. After receiving her degree, she taught grammar school on the island. Before long, de Burgos's work appeared in several Puerto Rican newspapers and periodicals. She sojourned throughout Puerto Rico, where she read from her published works. After she arrived in New York City, she failed to acquire employment befitting an educated woman of her stature. Tragically, she spent her remaining days in the neighborhood before dying of pneumonia at age thirty-nine. Since her death, de Burgos has been recognized as one of the greatest poets of our time.

Langston Hughes was a short story and children's book author. He was also a poet who was once referred to as the "Dean of Black Writers." He was born in Joplin, Missouri, and lived in Ohio and Nebraska before moving to Harlem shortly after he enrolled at Columbia University. Hughes became part of the Harlem Renaissance, which included Zora Neale Hurston and Claude McKay. He also traveled to Europe, where he befriended other literary giants such as Ernest Hemingway and Federico García Lorca. In 1947, Hughes moved from Central to East Harlem and resided at 20 East 127th Street between Fifth and Madison Avenues, where he spent the rest of his life. During that period, Hughes wrote *I Wonder as I Wander* (1956) and in 1960 received the Spingarn Medal, the NAACP's highest award for Black Americans' achievement. He published two children's books: *Marian Anderson: Famous Concert Singer* (1954) and the *First Book of Africa* (1964). Hughes also visited nearby Public School 24, recited poetry, and read to schoolchildren. His *Selected Poems of Langston Hughes* was published in 1958. Many celebrities visited Hughes's brownstone during his stay in East Harlem. He became part of the neighborhood and frequented many stores and bars in both Harlem and East Harlem.

The writer, screenwriter, and novelist **Ed McBain** (his pen name) or Evan Hunter (his legally adopted name) was born Salvatore A. Lombino (1926–2005) in East Harlem.

At age twelve, his family relocated to the Bronx. After serving in World War II, Lombino worked odd jobs to support himself. He had a short-lived career as a substitute teacher, which lasted slightly more than two weeks and became immortalized in his book *Blackboard Jungle*, published in 1954. The book was adapted into a film with the same title a year later, starring Sidney Poitier and Vic Morrow. By this time, Lombino had legally changed his name to Evan Hunter. He wrote the screenplay for Alfred Hitchcock's film *The Birds* (1962). Hunter's other successful novel was *87th Precinct*, written in 1958. A short-lived television series with the same title ran on television from 1961 to 1962.

Nicholasa Mohr is the grande dame of short stories and literature. She has authored fifteen books and taught at Queens College, Richmond College, and American University in London. Mohr has also written plays and screenplays. She lived in East Harlem on 100th, 105th, and 107th Streets before moving to the Bronx as a child. Her first book, *Nilda* (1974), was hailed by the *New York Times* as one of the year's ten best books. Accolades followed, and she received the Jane Addams Peace Award. Originally a graphic artist, Mohr, a self-taught writer, received encouragement from her agent to write about her life experiences. After a disappointing encounter with a prospective publisher, Mohr might have ceased becoming a writer. Instead,

she persisted, and eventually, her first book was published by Harper and Row. Her other notable works are *El Bronx Remembered* (1975), *Ritual of Survival: A Woman's Portfolio* (1985), and the children's book *The Song of El Coqui and Other Tales of Puerto Rico* (1995).

Willie Perdomo is a poet, writer, and children's book author. His works include *Essential Hits of Shorty Bon Bon* (2014), *Where a Nickel Costs a Dime* (1996), and *Smoking Lovely* (2003), which earned him the PEN Margins Award. His short story book, *Visiting Langston*, garnered him the Coretta Scott King Award. *The Crazy Bunch* (2019), whose wonderful poems formed the Poetry Cops (Consolidated Poetry Systems), won him praise in the *New York Times Book Review*, *Publishers Weekly*, and the *New Yorker* magazine. He won an award from the Foundation for Contemporary Arts, the Cy Twombly Award for Poetry, the New York City Book Award in Poetry, and the PEN Open Book Award. Perdomo is a Lucas Arts Fellow and an instructor at Phillips Exeter Academy.

Ernesto Quiñonez lived in East Harlem on 105th Street. Originally, he intended to be an artist, but his talent bloomed on the literary pages. Quiñonez continues the tradition of great and talented Puerto Rican and Latin American authors. His first book, *Bodega Dreams*, published in 2000, was lauded in the *New York Times Book*

Review, earned the Notable Book of the Year, and became an instant classic. Quiñonez followed up that success with *Chango's Fire* in 2004 and *Tiana* in 2019. Quiñonez teaches at Cornell University.

The author **Henry Roth** (1906–1995), originally from Austro-Hungary (now Ukraine), immigrated to New York City with his family. Upon arrival, the family settled in Brooklyn, New York, then Manhattan's Lower East Side. Roth and his family lived in East Harlem when he was eight years old. He left East Harlem at twenty-one in 1927 to live in Greenwich Village. Three years later, he began writing *Call It Sleep*. Completed in 1934, the novel received positive reviews but failed to generate great book sales. Republished three decades later, it became a best seller.

Piri Thomas (born Juan Pedro Tomas, 1928–2011) was born in East Harlem. Thomas lived in parts of the neighborhood during his youth, including on 104th Street between Park and Lexington Avenues. He moved to Long Island during his adolescence and occasionally returned to the neighborhood. During his early twenties, a botched armed robbery sent him to prison. After his release, he worked several jobs before receiving a grant from the Rabinowitz Foundation to write his memoirs. Released in 1967, *Down These Mean Streets*, an autobiographical book, became a best seller and has been in print for over half a century. His

other works are *Savior, Savior Hold My Hand, Seven Long Times*, and *Stories from El Barrio*. Thomas's work ushered in the Nuyorican authors' movement of the late 1960s and early 1970s.

Musicians

Several forms of musical genres have existed in East Harlem during the neighborhood's history. In El Barrio during the 1920s and 1930s, newly transplanted Puerto Rican immigrants arrived in East Harlem. Trying to acclimate themselves to their new environment was difficult at times. Work was scarce during the Depression. Music provided relief during this unstable period and became a buffer that connected Puerto Ricans from the island to the city.

Around the late 1920s, **Rafael Hernández** became the proprietor of Almacenes Hernández music store, which became the first of its kind to open in the neighborhood. According to the historian Virginia E. Sánchez Korrol, Hernández's students received musical instruction in the back of the store. His song "Lamento Boricano," recorded by Pedro Ortiz-Dávila, evoked memories of the island while simultaneously focusing on Puerto Ricans who struggled financially to survive in their new home. Trios (composed of three musicians or singers in one form or another) or *conjuntos* (bands) played in many apartments in El Barrio

during the weekends or special occasions: birthdays, holidays, and so on. Puerto Rican musicians were also part of the famed African American bandleader James Reese Europe's band, which traveled to Europe during World War I and became part of the Harlem Renaissance upon its return to the United States. Rafael Hernández and Juan Tizol were some of eighteen Puerto Rican musicians who participated in this historical role in Reese Europe's success overseas.

Puerto Rican women musicians also participated in the big band era. **Elsie Bayron** and later her younger sisters, **Grecia and Julia Bayron**, transplanted from Mayagüez, Puerto Rico, and lived in East Harlem, and all three sisters became entertainers. After Elsie was discovered, she moved to Spain and enjoyed a successful singing career. Grecia and Julia became musicians and achieved outstanding success as part of the International Sweethearts of Rhythm. This group performed with Duke Ellington's and Count Basie's orchestras. Their musicianship was comparable to Benny Goodman's band. They performed nearby at the Apollo Theater in Harlem.

Olga San Juan lived in East Harlem. Before she married the actor Edmund O'Brian and retired from show business, she had a successful singing and acting career.

Some Latin bands recorded their songs, and if they were heard on the local radio stations, this led to performing at many sold-out theaters. For example, standing-room-only events occurred at the Teatro Campoamor (Teatro Hispano) on 116th Street and Fifth Avenue. During the 1940s and 1950s, Latin music exploded in parts of the city. The East Harlemites **Tito Puente** and **Frank "Machito" Grillo**, who lived on 111th Street near Third Avenue, along with fellow Latin icon **Tito Rodríguez** played in lower Manhattan at the Palladium near 14th Street or in nearby Central Park. East Harlemites who lived on Fifth or Madison Avenue fondly recall ascending to the roof to hear these musicians perform outdoors.

The late 1960s brought a new Latin music form called the "Latin Boogaloo," a combination of Black American rhythm and blues or soul music and Latin beats (mambo). An early rendition of the Boogaloo can be heard in **Ray Barreto**'s "El Watusi." East Harlemites played a prominent role in the Latin Boogaloo period. **Joe Cuba**'s "Bang Bang" was cowritten with **Jimmy Sabater**, a percussionist. **Johnny Colon**, "El Maestro," scored with "Boogaloo Blues," among his many hits, and **Joe Bataan**'s "Gypsy Woman" was another of the hits from this genre. The musician and East Harlemite percussionist **Benny Bonilla** played on many of these songs. Bonilla's work can be heard on

"I Like It Like That" by the Pete Rodriguez Orchestra. In the song, you can hear the term "Boogaloo." In the 1970s and early 1980s, a new sound, salsa, was heard throughout El Barrio's underground social clubs and streets. The list of salsa musicians from the neighborhood is too long for this book.

The African American ensemble **Voices of East Harlem** was founded in 1969 by Chuck and Anna Griffin. Originally, the group was supposed to sing at small colleges and other small venues, until the group sang at a benefit for the former New York City mayor John Lindsay. That appearance garnered a manager and then a record deal with Elektra Records. The group released *Right on Be Free* in 1970. Two years later, its second album, *Brothers and Sisters*, led to moderate success with the single "Giving Love." The band broke up in 1974.

Photographers

John Albok (1894–1982) spent decades photographing East Harlem's people and places. He hailed from Munkacs, Hungary, which today is part of Ukraine. Albok immigrated to the United States in 1921. He was employed as a tailor, and his shop was located on Madison Avenue between 96th and 97th Streets, where he primarily photographed people and images near his tailor shop.

Helen Levitt (1913–2009) photographed images throughout the city. She took many photographic images in East Harlem from 1944 to 1948. In 1948, Levitt and James Agee filmed *In the Street*, a short film that documents life in East Harlem.

Hiram Maristany (1945–2022) was a neighborhood photographer born and raised in East Harlem (El Barrio). Maristany's work can be seen at the Smithsonian Institute. He was the official photographer of the Young Lords Party. Maristany also developed a friendship with Malcolm X (El Hajj Malik El Shabazz). He spent several decades photographing East Harlem.

Acknowledgments

While attending the Brooklyn Book Fair in October 2021, I encountered the book *Walking Harlem* by Karen F. Taborn, published by Rutgers University Press. Immediately, I liked the book and thought about how the East Harlem neighborhood would benefit if a tour book were published. Many tour guides who have visited East Harlem focus on the artwork (murals) that appear throughout the neighborhood. The artwork is beautiful and is recognized in this book. However, many historical edifices tell East Harlem's history, and many tourists and residents are unaware of this history. Unlike Harlem, home to the historically African American neighborhood and capital of Black America, East Harlem has always been a transitional neighborhood. Over a century ago, many southern and eastern Europeans, Jews, and Italians lived in East Harlem. Progressive and socialist leaders roamed the streets and promoted leftist causes. Puerto Ricans from the island and African Americans from the southern states later succeeded both groups. Today, Mexicans and other Latin Americans have moved to the

neighborhood and continue the revolving door of ethnic groups that called East Harlem home. The stores and businesses give credence that East Harlem's Latino community remains vibrant. Despite the ever-looming threat of gentrification, the neighborhood's population continues to grow as housing construction occurs throughout East Harlem.

The other profound difference between the two neighborhoods is that many tenements and buildings were demolished shortly before and after World War II in East Harlem. This destruction resulted in the loss of businesses, led to the residential relocation of thousands of people, and, more importantly, eradicated part of East Harlem's history. But all was not lost. This book details how many buildings still stand tall and remain intact despite the urban renewal that transpired during the past century. Thanks to the historian Herb Boyd for his support; Rutgers University Press and especially Peter Mickulas for allowing me to inform many who want to visit and learn about East Harlem; professor emeritus and Manhattan historian Robert Snyder of Rutgers University for his insights and historical input; J. E. Molly Seegers, director of The Arthur H. Aufses, Jr., MD Archives and Mount Sinai Records Management Program; Arlene Shaner, historical collections librarian, New York Academy of Medicine; Jonathan Kane of Photographs of the Art Kane Archive; Sarah Henry of the Museum of the City of New

York; Andrea Felder, permissions and reproduction services, New York Public Library.

Finally, thanks to Ana Roman of Fortune Consulting for her outstanding proofreading, copyediting, and editorial comments.

Bibliography

Aufses, Arthur H., Jr., MD. Archives. https://archives.mssm.edu/
aa116-s001.

Aufses, Arthur H., Jr., and Barbara Niss. *This House of Noble
Deeds: The Mount Sinai Hospital, 1852–2002.* New York: New
York University Press, 2002.

Caribbean Cultural Center African Diaspora Institute. "About:
Mission & Vision." http://cccadi.org/mission-vision.

CentralPark.com. "Museum Mile Festival 2022." www.centralpark
.com/events/museum-mile-festival-2022/.

Central Park Conservancy. "Conservatory Garden." www.central
parknyc.org/locations/conservatory-garden.

Cinema Treasures. http://cinematreasures.org.

"City to Demolish Greenhouses." *New York Times*, November 8,
1934.

Congregation Ansche Chesed. www.anschechesed.org.

El Museo. https://www.elmuseo.org.

Fazzare, Elizabeth. "An Iconic New York City Theater Just Com-
pleted a Major Renovation." *Architectural Digest*, August 26,
2019. www.architecturaldigest.com/story/iconic-new-york
-city-theater-completed-major-renovation.

Forgotten New York. "Upper Fifth Avenue, Harlem: Part 1."
November 22, 2015. https://forgotten-ny.com/2015/11/upper
-fifth-avenue-harlem-part-1/.

Harlem Bespoke. "Remember: 141–145 East 103rd Street." http://
harlembespoke.blogspot.com.

H.R. 282—105th Congress: To designate the United States Post
Office building located at 153 East 110th Street, New York,
New York, as the "Oscar Garcia Rivera Post Office Building."
Public Law 105-87. 111 Stat. 2113. November 19, 1997. www.gov
info.gov.

Landmarks Preservation Commission. Benjamin Franklin High
School (High School for Mathematics and Science). March 27,
2018. Designation List 505, LP 2596

———. Church of All Saints Parish House and School. January
30, 2007. Designation List, LP 2165.

———. First Spanish Methodist Church (aka the People's
Church). December 12, 2017.

———. Harlem Courthouse. August 2, 1967. Designation List,
Number 3, LP 0297.

———. Langston Hughes House. August 11, 1981. Designation List
146, LP 1135.

———. Museum of the City of New York. January 24, 1967. Num-
ber 8, LP 0448. https://www.mcny.org.

———. Public School 109 (Now El Barrio Artspace). March 27,
2018. Designation List 505, LP 2597

———. Richard Webber Packing House. March 27, 2018. Designa-
tion List 505, LP 2595

———. Saint Andrew's Church. April 12, 1967, Number 1, LP 0294

———. Saint Cecelia Church. September 14, 1976. Designation
List, Number 3, LP 0933.

———. 17 East 128th Street House. December 21, 1982. Designa-
tion List 162, LP 1237.

———. Thomas Jefferson Play Center. July 24, 2007. Designation
List 394, LP 2236

———. 28th Precinct Station House (Now Hope Community Hall). Designation List 302, LP 3064.

———. Watch Tower Center of Mount Morris Park (Marcus Garvey Park). July 12, 1967. Number 4, LP 0313.

MNN El Barrio Firehouse Community Media Center. https://www.mnn.org/locations/firehouse.

Pleasant Village Community Garden. https://www.pleasantvillage communitygarden.com/.

Sanchez-Korrol, Virginia E. *From Colonia to Community: The History of Puerto Ricans in New York.* Berkeley: University of California Press, 1983.

Serrano, Basilio. *Puerto Rican Pioneers in Jazz, 1900–1939: Bomba Beats to Latin Jazz.* Self-published, iUniverse, 2015.

———. *Puerto Rican Women from the Jazz Age: Stories of Success.* Self-published, AuthorHouse, 2019.

Index

About the Author

CHRISTOPHER BELL holds a master's in history from City College. He is the author of *Images of America: East Harlem*, *Images of America: East Harlem Revisited*, and *East Harlem Remembered: Oral Histories of Community and Diversity*. He has given tours, lectured, and presented at the Museum of the City of New York and has appeared in *E Harlem TV*, *MNN*, the *New York Times*, and *New York Daily News*.